PAULA BRIGGS

MAKE BUILD CREATE

SCULPTURE PROJECTS FOR CHILDREN

PAULA BRIGGS

MAKE BUILD CREATE

SCULPTURE PROJECTS FOR CHILDREN

black dog
publishing
london uk

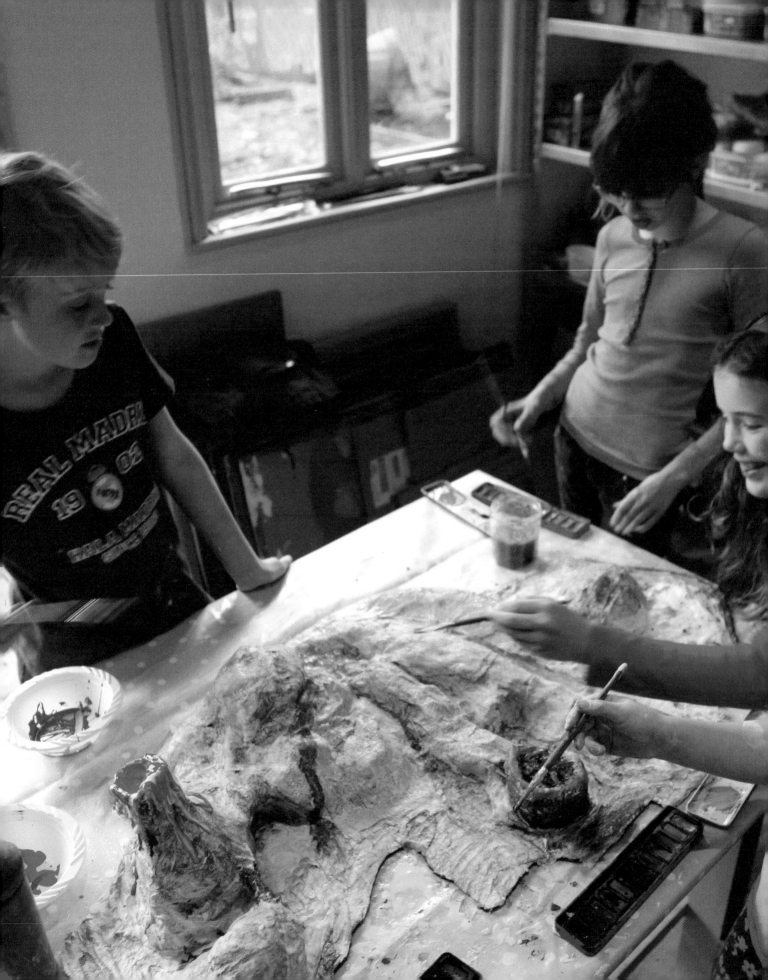

THE NEW MANIFESTO FOR MAKING

Let's be proud of our ability to make things and get more people making. Makers are brave people: putting an idea out into the world and making it real takes guts!

Thank you!

It's great that:

> You like making.
> You can see the potential in transforming the world around you.
> You are inspired by things you see.
> You enjoy seeing how other people make things.
> You enjoy making things alone.
> You enjoying making things in groups.
> You like the things you make and are proud of what you've done.

When you are making, remember:

> It's OK to make a mess.
> It's OK to keep trying.
> It's OK to start again.
> It's OK to be inspired by someone else.
> It's OK to take risks.
> It's OK to get sore fingers.
> It's OK to get annoyed when something falls over.
> It's OK to not always know what you're doing.
> It's OK if things go wrong!

I declare I am PROUD of My Ability to MAKE Things, and I Will MAKE SURE that I MAKE Things Every Week!

Signed:

CONTENTS

Projects

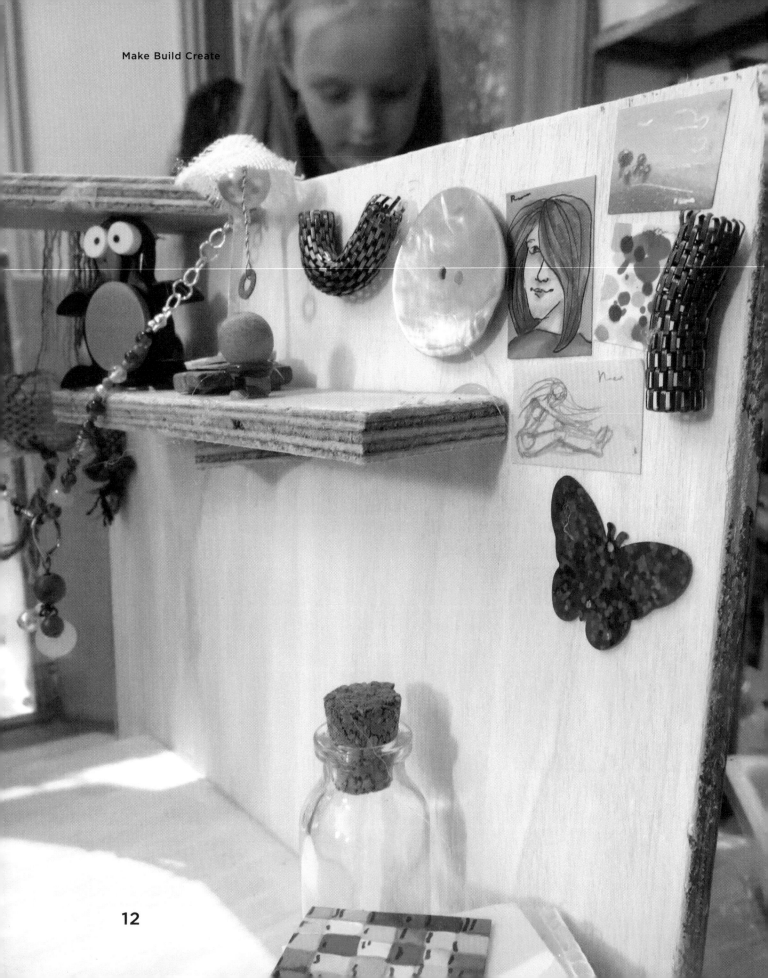

YOUR OWN GIGANTIC, MINI WORLD

I want to inspire you. I hope you have picked up this book because you like making things. Perhaps you are drawn to the end results, or perhaps you know you enjoy the process of finding materials, sticking them together and putting things out in the world.

Making sculpture, building models and creating stuff is a fantastically optimistic thing to do. It is never a waste of time, to sit with a pile of materials, your hands, your imagination. You will know that fantastic feeling as a small idea drops into your head, your fingers start to move and you begin to create.

In lots of ways you do not need the help of others. Your wonderful brain and your urge to make is more than enough to create the most fantastic things—things no one has made before, things that did not exist until you brought them into the world.

But do get adults to help you. Ask them to collect materials for you to make with (they're often free). Ask them for help with things like glue guns, which when used responsibly under adult supervision will open up a whole new world of making to you. Ask them for help in creating the time and space for you to make (and for putting up with the mess!). And most of all, remind them to value what you make, by showing them how proud you are, and how connected you feel to the things you make.

So imagine, before you get started, a whole gigantic, mini world that you have made. Imagine a collection of objects and sculptures and models and things, all jostling for space. Imagine them filling a room, connecting with each other, creating a whole new universe; objects made real from the ideas in your head and shared with the world. There is no limit to what your world might contain. Just think how proud you will be.

This is your world, which comes out of your head, your own making journey! So get making!

Make Build Create

14

MAKING: "AN INCONVENIENT BUT VERY IMPORTANT TRUTH"

There are so many reasons not to make, and we need to talk about them:

— Making takes time and energy, and making with a class of 30, or even a household of two or three, can be exhausting.

— There's more than enough to be getting on with. Pressure from other subjects means making and the arts can get squeezed out of school. Homework impedes on spare time at home, which might otherwise be spent making.

— Making creates mess. Wouldn't it be nice if we could make like a singer sings (without mess to clear up afterwards)?

— Making can be risky. A child might burn their finger on a glue gun, or cut themselves with a saw.

— There's more than enough stuff in the world so do we really need to make more?

— Making uses resources, and aren't we meant to be trying to use less resources?

— We don't need to make to survive. We generally buy what we need so we don't need to learn the skills first-hand any more.

— We don't need to make to entertain ourselves. In the past we might have kept our hands and eyes busy with making in our spare time, but now we occupy ourselves with entertainment on demand.

And yet... when we give children the time and space to make, and present them with a pile of materials, they fall to it with such a will. Like children who gorge on sweets at a sweet shop after being barred from eating sweets, the appetite to make is there, even when no one speaks of it. Making connects the hand, eye and brain in a very special way. Making is empowering, for both the maker and viewer. The act of making is an optimistic act, and act of faith. And people of all ages feel better for making. Making can be very social— conversations can meander whilst hands are kept busy, but making can also be very personal, and it can give confidence to children who listen to their own internal monologue that takes place as they make in solitude. For the hands and brain to be occupied in this way is very therapeutic. And of course if we want a world full of creative, entrepreneurial thinkers, then we need to enable making from a very young age. We may not all become sculptors or engineers or designers, but we will definitely become more connected, rounded, creative people.

For many years my colleague Sheila Ceccarelli and I have been working at UK charity AccessArt to ensure we continue to promote, support and enable making at all levels.

So whilst making may sometimes seem inconvenient, we really do need to find the time, space and resources to make it happen. I hope this book helps inspire you to do just that.

Paula Briggs, AccessArt, www.accessart.org.uk

MATERIALS, TOOLS, TECHNIQUES

WORKING WITH PLASTER

Plaster of Paris (or fine casting plaster) is produced by heating gypsum. It is used in a powder form that is then mixed with water. When the powder is mixed with water the plaster undergoes an exothermic reaction. The plaster then hardens over time into a strong material that can still be carved.

When used with care and sensible precautions plaster can be a very useful sculptural material, even with young children. For many sculptural projects you will be able to use modroc instead of plaster (p 28), but sometimes only liquid plaster will do! In conjunction with other materials plaster can be used for modelling, casting and construction.

Follow these tips and enjoy using plaster safely as a great sculptural enabler.

MIXING PLASTER

Materials and Equipment:
— Plaster of Paris
— Two buckets
— Access to water

Before you mix the plaster, have your sculpture, whether it is a construction or cast, ready.

1. Pour clean water into a clean bucket. You will be adding dry plaster to the bucket, so never fill the bucket to more than half full of water.

2. Following all safety precautions listed below, add plaster to the bucket a handful at a time. Do not get your hand wet when you add the plaster to the water, instead just gently drop the plaster in from just above the water level.

3. Keep adding plaster handful by handful, ensuring you drop it evenly into the bowl.

4. DO NOT MIX THE PLASTER. Let each handful of plaster fall to the bottom of the water. As the plaster begins to back up, and as the water becomes more saturated, it will take longer for each handful to sink.

5. You will know when you have added enough plaster, as small 'islands' of plaster will form on the surface, and finally these small islands will not sink.

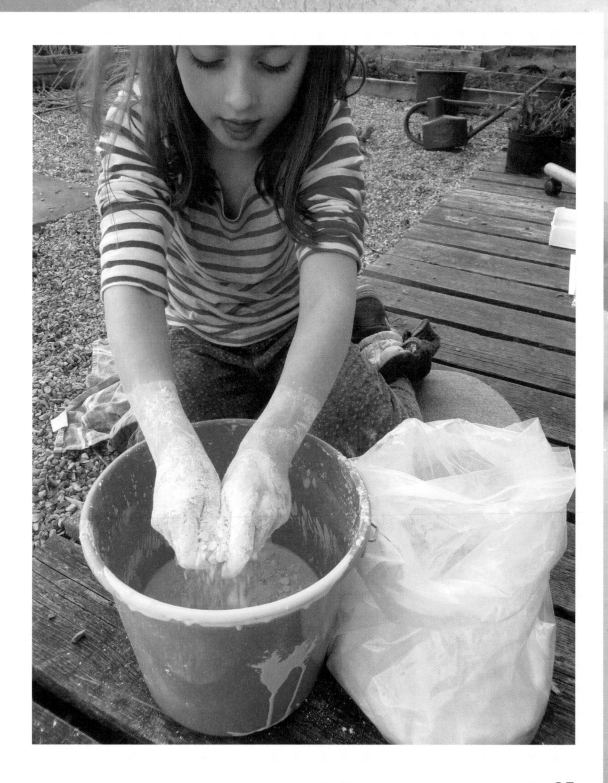

6. At this stage do not add any more plaster.

7. Using your hand, and following the safety precautions below, mix the plaster. Reach right down into the bucket, squashing any lumps with your fingers, and then gently stir the whole mixture (do not forget the sides and base of the bucket).

8. You can check the consistency at this stage. When you bring your arm out of the bucket the plaster should coat your arm like cream or thick yoghurt. If you think the mixture is too runny, you can add another handful of plaster but stir it very well.

9. Make sure you don't leave your hand in the bucket whilst the plaster sets. At this stage you can pour the plaster if you are using it to cast, or add small pieces of scrim (an open weave jute-based fabric) that can be dipped into the plaster to be used as a construction material.

10. You have a window of about five to ten minutes to work with the plaster, so it is better to mix too little rather than too much, especially on a construction-based project, and then you can mix more.

11. Leave the plaster to undergo its chemical reaction. Do not continue working the plaster at this stage, as you will destroy its chemical structure.

12. Once the plaster is set, you can then continue with your sculpture (if it is cast you can peel away the clay mould). Over time the plaster will dry out.

13. Plaster can be carved at any stage. When the plaster is still wet there will be less dust (just a wet slurry). Once the plaster is dry, any carving should be undertaken in a well-ventilated area, wearing mask and eye protection.

14. The surface of the plaster can be treated with any water-based paint when the plaster is wet or dry, and varnished or worked with oil-based paint when it is completely dry.

STORING PLASTER

In its powder form, plaster does not last indefinitely. To keep the plaster fresh for as long as possible store it in an airtight container in a dry environment.

PLASTER OF PARIS SAFETY

When working with children of any age, only use plaster under close supervision.

To protect yourself and others from plaster dust, use in a well-ventilated area, and wear dust masks. Plaster dust can be drying to the skin so protect hands by wearing latex gloves or applying petroleum jelly as a barrier cream.

As plaster undergoes an exothermic reaction, during the setting stage, it heats up and can become hot. Never use Plaster of Paris directly against the

skin to cast body parts. Never submerge hands or other body parts in a bucket of liquid plaster and wait for it to set. As the plaster heats up and sets, you will be unable to get your hands out resulting in severe burns and other injuries.

Never drink or otherwise ingest plaster dust or mixed plaster.

STUDIO TIPS

Never pour mixed plaster down a drain, unless it has a plaster trap. Instead pour any water containing plaster into a bucket and allow the sediment to settle. You can then pour off the water into an external drain and scoop out the plaster debris. If you have some plaster left over, leave this to set in the bucket and once it has set, tap it out and put it into the bin.

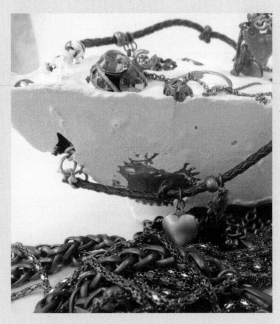

USING MODROC

Modroc is another name for plaster impregnated bandage, and it can be used to make sculpture by even very young children (who love the messiness!) or by older children who enjoy its versatility.

Modroc is extremely versatile and can be used for making all kinds of modelling, casting or construction based sculpture. Modroc can be used over an armature or framework, which can be made in a number of ways depending upon age, ability or purpose. It can also be used alone to form home-made plasterboard with which you can then construct (p 48).

BUYING AND STORING MODROC

As modroc keeps relatively well if it is kept in a dry place, it may be worth buying larger quantities. You can buy modroc in large sheets that you then cut to size—ideal for larger projects or big classes. You can also buy it in smaller, individually wrapped packs that help keep it fresh.

SETTING UP YOUR SPACE

Modroc is quite messy, though the mess can easily be contained with a bit of forethought.

1. Cover the table (or floor if you are working on a larger project) with plastic or newspaper. If you are working with children then working on tables cuts down on much of the mess (less feet to walk the mess around the room!).

2. Cut your modroc to size before you start work (make sure you do not get the modroc wet before you start using it). Small pieces (approximately 10 x 5 cm/4 x 2 in) are ideal for children working on smaller projects. Larger pieces (20 x 20 cm/8 x 8 in) can be used for larger projects.

3. You will need access to water and a water container to dip your modroc in. For children, a large yogurt pot or plastic tray is ideal, and for larger projects a small bowl or bucket can be used. You'll also need a second bigger bowl or bucket to pour your old water into.

4. Have a towel ready for messy hands!

USING THE MODROC

1. Have your sculpture ready, and then dip a piece of the modroc into clean water. Let it soak for a moment, then lift it out, squeeze off some of the water, and drape or mould it over your sculpture.

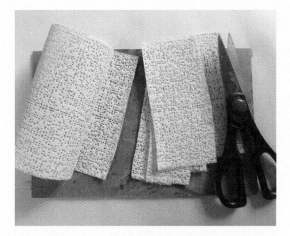

2. Most important! Once the wet modroc is on your sculpture, and before it sets, you need to use your fingers and hands to mould the modroc, getting rid of all the little holes you can see in the bandage.

3. Keep dipping and moulding, building up your sculpture. Small sculptures will need only one or two layers; larger sculptures might need more layers.

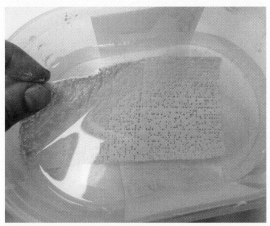

4. Most important! Make sure your water is always clean before you dip your modroc into it. Water that is too cloudy will prevent your modroc from setting.

5. You can also use small pieces of modroc to add detail to your sculpture, modelling the materials between with your fingers.

6. When you are happy with your sculpture, leave it to set. You can always add more layers later if you need to (on top of the dry modroc). The modroc will take between one and four days to dry out, depending on the room temperature.

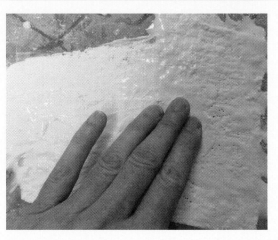

ONCE THE MODROC IS DRY

The modroc will be dry when the surface no longer feels damp and instead feels slightly more 'powdery' or 'chalky'.

Modroc can be painted with any water-based paint (powder, gouache, acrylic, watercolour), or even oil-based paints (but make sure the modroc is COMPLETELY dry). For a more durable paint finish you can also mix PVA glue with the paint, or use the PVA as a varnish.

You can also use the PVA to stick fabric over the modroc.

If you need to build on top of your modroc with more modroc, make sure you soak your sculpture in a bucket of water before you add extra modroc as it will key better to a slightly damp surface. The modroc underwent an exothermic chemical reaction when you initially soaked the plaster bandage, so soaking dry modroc in water will not turn the modroc back to a modelling material.

ALTERNATIVES TO USING MODROC

If you are making large sculptures, or a lot of smaller sculptures, it will be cheaper to use builders scrim and fine casting plaster.

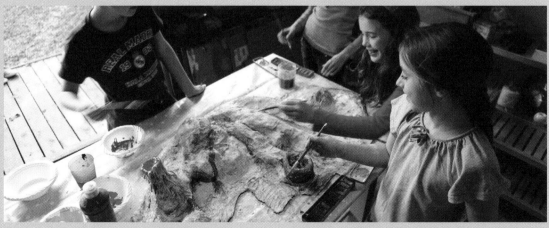

TOP TIPS!

Always ensure the water you use to dip your modroc into is clean—when the water looks very cloudy pour it into a bucket and get some fresh water. Dipping plaster bandage into cloudy water will impair its ability to set. NEVER pour the modroc water down a sink that has NOT been fitted with a plaster trap. The particles of the plaster will block the sink. You can make a homemade plaster trap, or more simply just have a couple of buckets ready to pour the cloudy water into. Once the plaster has settled you can safely and carefully pour the water down an external drain, and scoop the plaster debris into a bin.

Control the dust from the modroc, especially at the cutting stage. Use modroc in a well-ventilated room and follow the health and safety tips.

HEALTH AND SAFETY

Use in a well-ventilated area. If you are using a lot of materials that create dust consider fitting a simple extractor fan. You might also want children or adults to wear a simple mask to cut down on any inhaled dust. Larger masks are cumbersome and usually end up not being worn. Small masks can help cut down on inhaled dust and are less obtrusive to wear, and therefore more likely to get worn.

With excessive use, or for people with sensitive skin, modroc can cause skin irritation. If this will be a problem then take precautions—use a barrier cream such as petroleum jelly prior to use, or wear thin latex gloves (if you have no allergy to the gloves). Thick gloves make it impossible to use the modroc and so they are impractical. Plaster and modroc become warm, and sometimes hot, as they set, so never use them to directly cast a body part.

INTRODUCING CLAY

Clay is a versatile material that can be used in many ways to make and create sculpture. That said, many children have little or no experience of working with clay. Most clays require a kiln to fire the material to a more durable state, and as most people do not have access to a kiln, many opt for the air dry clay available. While air dry clays have their uses, they are generally more expensive than standard 'school' clay and as they contain filaments of nylon to help reinforce their structure, they can also be harder to work with, seeming less plastic than many traditional clays. Try air dry clay, but be aware that it never sets as hard as fired clay.

For many of the projects in this book, and for the sheer enjoyment and experience of working with clay, we recommend buying cheap school clay (terracotta or buff). This can be used both as a modelling, construction or casting material. Even without access to a kiln, school clay should be recognised as a medium in its own right, even though the work produced will be more temporary in nature.

There are many simple clay techniques that children will learn quickly and easily, and over time skills will develop. Initially, however, keep it simple by following these tips:

— Assuming that the clay is fresh, children should not need too much water to work with clay. Of course they can work water in to the clay to create a slip that is useful for fastening and joining, or to push the nature of the clay to see where it goes, but in general, for the projects in this book, keep water to a minimum. This will also help control mess.

— By all means encourage children to explore the use of clay tools in their work, but also encourage them to use their hands. They will quickly build up a body of empirical knowledge about how the clay responds to the pressure of hands and fingers.

— Work on small boards of cardboard or wood to ensure that projects are moveable.

— Clay makes an ideal mould making material and very simple casts can be made by pushing objects into a slab of clay that is then filled with plaster or modroc. Peel the clay off whilst it is still

wet. Never use clay that has been used with plaster in a kiln.

— You can even print monoprints from clay. Either create marker pen marks on a piece of paper and then roll a slab of clay over the paper and lift the clay up (the print will be on the clay). Or roll out a slab of clay, use ink or paint on the clay and whilst it is still wet lay a sheet of paper over the clay, press and lift.

— Be aware that dry clay turns to dust very quickly, especially pieces of clay that are dropped on the floor. Clay dust (silica) should not be breathed in. Prevent clay dust before it occurs by cleaning all spillages before they dry.

— As with all materials, be experimental, take risks and have fun. Do not be overwhelmed by the material and all the techniques it brings with it—just regard clay as yet another material that can help your making journey!

FOUND AND COLLECTED MATERIALS

In addition to the more obvious sculptural materials used in this book, such as clay, wire, wood and plaster, children will be inspired by a wide selection of found and collected materials.

The richer the selection of materials the more the imagination will be fed, and the bigger the choice, children will learn the skills to choose the right materials for the right job. Dismantling some materials down into their constituent parts will provide an even greater choice.

Collect over time the following materials:

— Wood (large and small pieces, in particular pieces that children can construct with, including pre-cut items like lolly pop sticks, skewers, pegs, matchsticks, garden canes, willow sticks, wooden beads...)

— Wire (in addition to iron wire (p 37), collect garden wire, florists wire, jewellery wire, paperclips...)

— Fabric and wool (old clothes such as jumpers, sheets, offcuts, samples (fabric sample books are useful), leather offcuts, string, thread...)

— Paper and cardboard (recycled (including old books, paper bags, envelopes, letters, magazines, newspapers), cheap newsprint and sugar paper, tracing paper, brown paper, graph paper, corrugated cardboard from boxes, paper trays...)

— Household items (dishcloths and sponges, dusters, tea towels, bath towels, bottles and cans...)

— Pieces of metal and ironwork (hinges, nails, screws, washers...)

— Old jewellery (dismantled necklaces, beads, pendants, chains, brooches...)

— Other interesting forms (old keys, brushes, shoes, watches...)

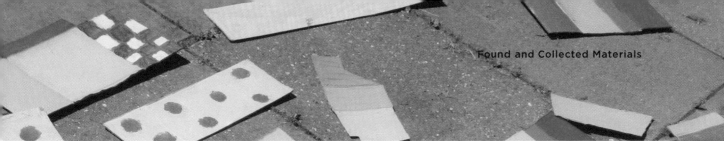

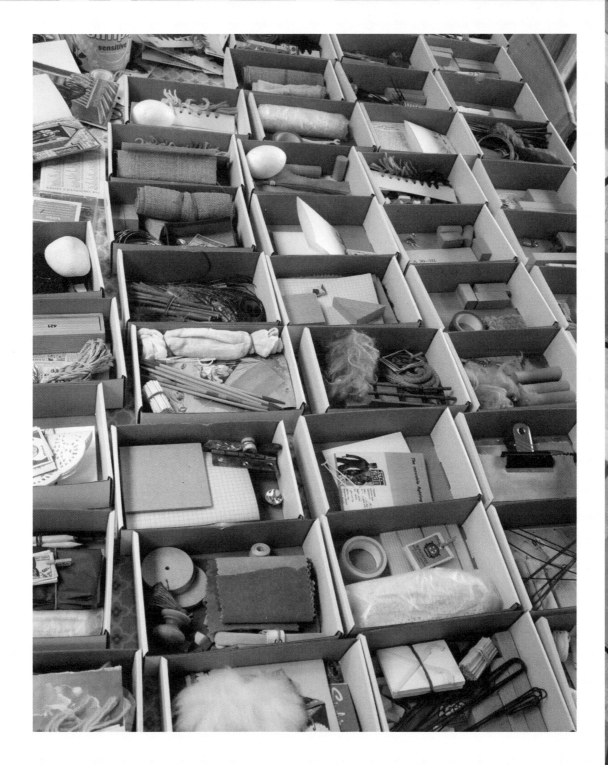

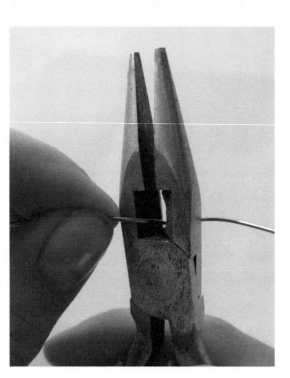

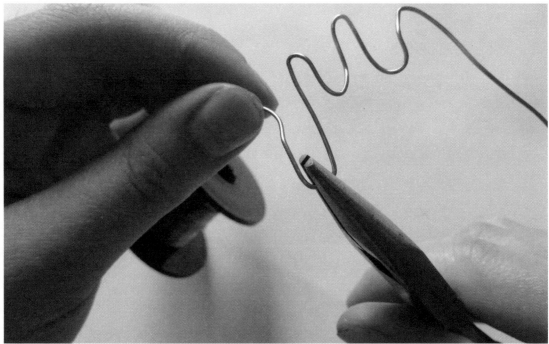

WORKING WITH WIRE AND USING PLIERS

Whilst there are many types of wire available, iron wire is an ideal sculptural choice for children. For "drawing in space" or binding choose a gauge around 0.75 mm/$\frac{1}{32}$ in. This wire will be strong enough to hold its shape, but malleable enough for small hands (especially small hands using pliers) to bend into shape and cut. Thicker gauge iron wire (up to 1.5 mm/$\frac{1}{20}$ in) will be useful in constructing armatures and can still be cut and bent relatively easily.

Wire-working tips:

— When using long-nosed pliers to bend wire, hold the pliers in your dominant hand and try to use the pliers instead of your fingers. This way using the pliers will become second nature. If you keep putting the pliers down after every use you will find yourself using your fingers to bend wire, which is not nearly as effective.

— When joining two pieces of wire, never join them at the end of a piece of wire.

This makes it hard to bind the wire tightly. Instead join the wire leaving a long section to neatly and tightly bind round the first piece of wire. Use the long-nosed pliers to help you.

— Just two pairs of pliers will make working with wire so much easier. A pair of long-nosed (or needle-nosed) pliers can be used to help bend wire, and to cut thin pieces of wire, whilst a small pair of wire cutters can be used to cut slightly thicker wire.

— Use the 'eye' of the pliers (the small circle near the joint of the pliers that contains a sharp edge) to cut the wire.

— Wear safety goggles whenever there is a risk of pieces of wire flying through the air, or to protect eyes from the ends of long pieces of wire.

— Always cut with the pliers at right angles to the wire.

USING A GLUE GUN

As pressure is applied to the trigger of the glue gun, the glue pellet is forced through the heated end, causing the glue to melt. At this point glue can be applied directly to the material to be joined. When the glue cools (within minutes), it sets, providing an easy way to help children construct quickly and effectively.

Follow these tips to ensure even young children can use a cold melt glue gun safely.

— When using glue guns with children opt for the cold melt version that heats to around 130°C/260F.

— Ensure your workspace is tidy.

— Allow ten minutes for the glue gun to warm up.

— When you are ready, press the trigger to release the glue.

— Once you have applied glue to one surface, attach the second surface immediately.

— Replace the glue gun pellets at the back of the gun when necessary.

Always buy pellets that are appropriate for your glue gun.

— Do not leave a glue gun plugged in for an extended period of time—even cold melt glue guns can become very hot.

— Never touch the end of the glue gun.

— Never touch the melted glue directly.

— Have ready access to cold water or ice (but never near the glue gun or electricity supply) in case any child gets glue on their skin.

— Always supervise children's safe use.

Use Cold Melt Glue Guns to stick (all surfaces should be clean and dry):

— Fabric
— Corrugated cardboard
— Foam board
— Plastics
— Metals
— Perspex
— Wood

Always consider if there are better glue choices for your needs. Thin paper or card, or thin fabrics will always be better suited to PVA type glue.

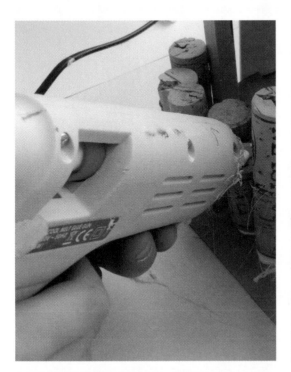

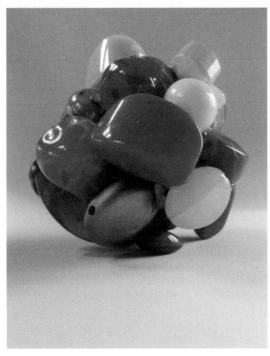

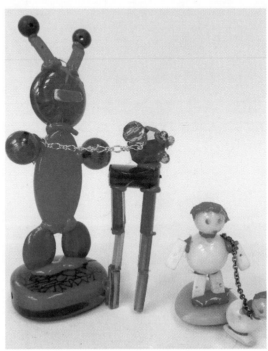

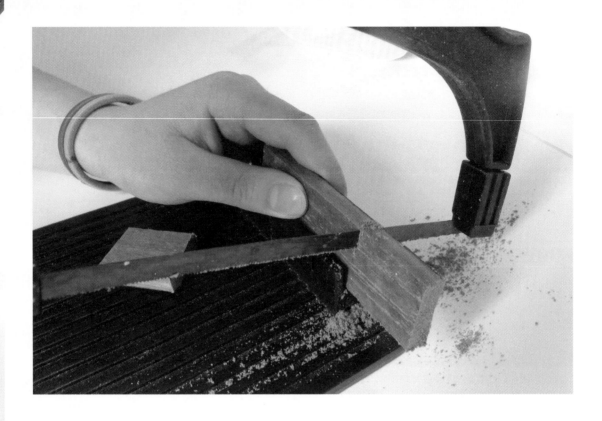

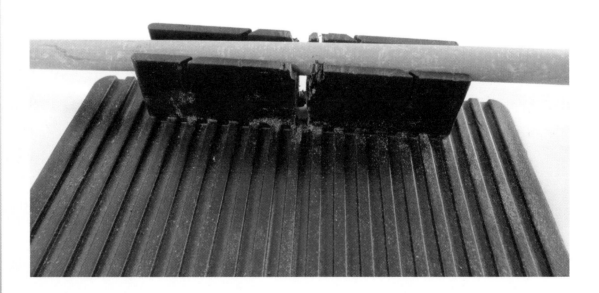

USING A HACKSAW AND BENCH HOOK

Bench hooks are not designed to be used with hacksaws but they can actually work really well. Follow these simple guides and even very young children can successfully use a bench hook and hacksaw.

— Use small amounts of Blu-tack under the bench hook to stop the bench hook sliding about on a plastic table.

— Check your position when sawing.

— Stand up.

— If you are right handed, place your left foot back. If you are left handed, place your right foot back.

— You should be able to see a straight line down your arm and through to the saw, otherwise the saw may jam.

— Hold the saw by the downward facing part of the handle, not by the top.

— Push forward. Let the saw do the work.

— Use your non-dominant hand to hold the material and bench hook in place by pushing it away from you.

— Hold materials as close as possible to the cut to restrict vibration from the saw, but be mindful of fingers.

— Hacksaw blades cut in one direction, but it is possible to put a blade into a hacksaw to face either direction.

— Be mindful of the last cut. The material may give suddenly and you may hit your knuckles on the bench hook.

— Wear safety glasses if the material is dusty.

Things to cut with a bench hook and hacksaw:

— Small diameter pieces of wood: up to 2 cm/¾ in
— Small diameter metal pieces
— Canes
— Withies (willow sticks)

THE SCULPTURE CONVERSATION

Before you start making sculpture with children it is always worth introducing a few key concepts at the beginning of the session which you can then refer to throughout the project. Ideally these should involve a dialogue with the children so that they can have feedback on their ideas, adding to their understanding.

Here are a few pointers to encourage an open-ended, enquiry-based approach to making:

— Begin with a conversation about sculpture. What is it? How is it different from painting or drawing? What does it mean if something is 3D and how does that affect the way you interact with it as both maker and viewer?

— Talk about work being individual and unique to the person who makes it. Introduce the idea that the whole world is full of material waiting to be transformed through their hands into something special.

— Discuss the idea of creative risk taking. When should they avoid risks, and why might they take risks? And what might the outcomes be, both good and bad?

— Acknowledge that making things can be hard work, both mentally and physically. Something can break just at the point you are getting tired and fed up with it. Reassure children that just because making things can be hard, it does not mean that they are not good at it. It just means that they are doing it!

PROJECTS

PAPER MANIPULATION

Being able to transform a flat sheet of paper into a three-dimensional form is a very useful skill. Have fun playing around with some sheets of paper and try these techniques (and invent your own!) and then try some of the projects referenced below.

MATERIALS AND EQUIPMENT

— Cartridge or thicker weight paper
— Scissors
— Glue stick

ACTIVITY

1. You can manipulate paper in many ways, and depending on your personality you might enjoy working in a precise way, or a rough and ready way! As you work through the ideas below, look out for ideas that present themselves to you and follow your instinct!

2. First of all, take a flat sheet of paper and screw it up into a ball! You have a sphere! Now carefully unfold the paper, and now you have another kind of form altogether!

3. Take some scissors and fold a sheet of paper neatly in whatever way you wish. Make some snips along the folds, open it out and see what you have.

4. This time scrunch the paper and then make the snips. How does the end result look?

5. Make some long cuts in some paper and then curl them backwards.

6. As above but curl them backwards and stick them down.

7. Make some long cuts and plait the paper.

8. Try all of the above but tear instead of cut. Or cut and tear in the same sheet.

9. How would you cut into the sheet in a freehand way to make a shape that can be folded into a cube? Or cylinder? Or cone? What happens if the sheet you work with has been used before and is full of holes?

10. What happens if you tear a sheet into small pieces and glue them together again?

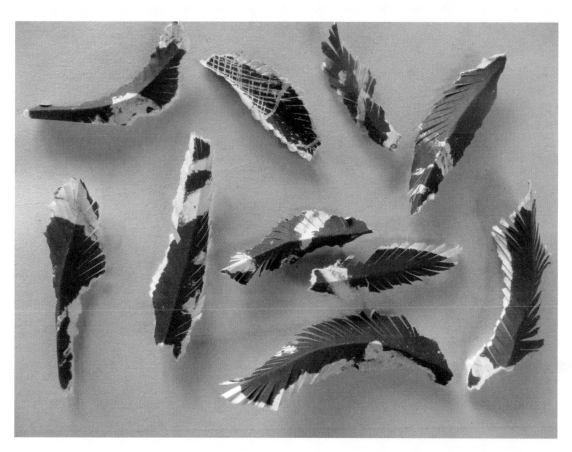

11. What happens if you try all of the above on paper that is coloured on one side?

By now you should have quite a collection of beautiful shapes of paper. Have a look at the following projects to put your skills to good use:

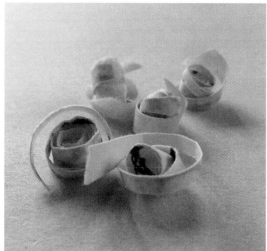

 Life-Sized Fashion (p 98).
 Constructed Maps (p 110).
 Making a Tree House Sculpture (p 118).

MAKING PLASTERBOARD

Everyone likes using building bricks to make amazing creations. Make your own pieces of plasterboard and you have a versatile construction material with which to keep building!

MATERIALS AND EQUIPMENT

— Scraps of paper
(coloured, printed, whatever you like)
— Modroc strips
— Scissors
— Bowl and water

ACTIVITY

1. Choose a flat surface on which to work; a plastic table or piece of oilcloth is ideal. Place your paper face down on the flat surface. Make sure the paper is the size of the piece of plasterboard you want to make.

2. Dip a piece of modroc into the water and squeeze off any excess water.

3. Lay the modroc down on top of the paper and use your hand to push the modroc smooth. Add further pieces of modroc until all the paper is covered,

making sure all pieces are pressed flat into the paper. Make a second layer of modroc over the first, this time with the pieces of modroc going in the opposite direction. The more you smooth and flatten the sheets the stronger the finished result.

4. Continue making plasterboard pieces. Leave them to set (approximately 20 minutes) and then gently lift the paper and modroc (which will now be combined) off the table. Using a spatula or fish slice may help.

5. Let the pieces fully dry out over night. Once completely dry, you can then cut, fold, bend or roll them into shape.

What to Build with Plasterboard Pieces

Use your plasterboard pieces to construct architecture, landscapes, animals or figures. You can fasten pieces together in many ways; make holes in pieces and sew them together with thread or wire, make cuts and slot them together, or (when dry) use paper and glue, or even more modroc.

FACILITATOR'S NOTES

This project provides an alternative way to use modroc, which is more often used as a modelling material. See how to use modroc (p 28).

MINI MAGNETIC SCULPTURES

Not all sculpture takes time or makes a mess! Enjoy making these quick sculptures and exploring form. Take photographs at each stage so you have a record of your work.

MATERIALS AND EQUIPMENT

— Rare-earth magnet
— Assortment of iron-containing metal objects of different shapes and sizes
— Camera (optional)

ACTIVITY

Experiment and play! Try not to fight the magnetic force, instead just go with it and build your sculptures as the magnet directs.

FACILITATOR'S NOTES

This activity may not be suitable for younger children or children who may be tempted to put the magnets in their mouths. Using a larger rectangular magnet may help discourage this.

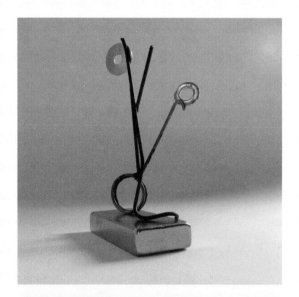

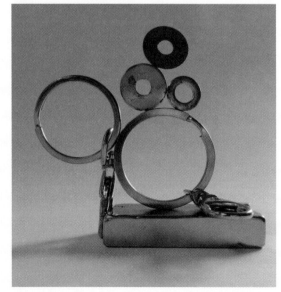

50

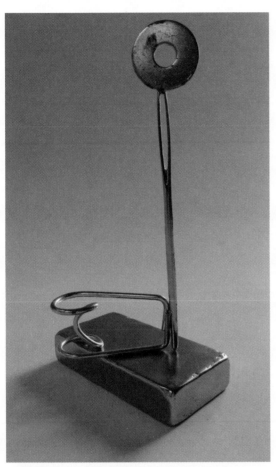

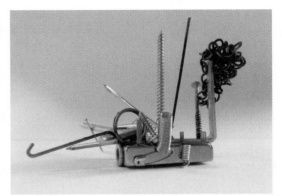

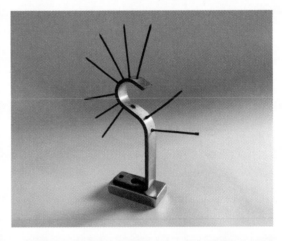

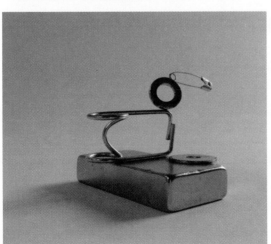

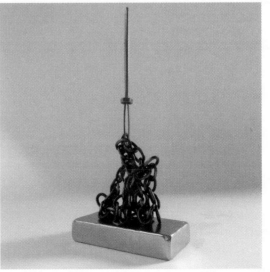

TREASURE ROCKS

Learn how to mix plaster, carve with a spoon and find treasure in this simple sculptural activity!

MATERIALS AND EQUIPMENT

— Small plastic food bag
— Plaster
— Sawdust
— A selection of beads, plastic or old coins (for the bits of treasure)
— A spoon

ACTIVITY

1. Take a small plastic food bag and add 6 to 8 cm/2 to 3 in of water. Add the treasure and hold the bag open and tight for the next part!

2. Using your hand or a spoon, add plaster and sawdust to the water in a ratio of approximately 3:1. Do not let your hand or the spoon get wet as you add the ingredients; gently drop them in from just above, but not touching, the water level.

3. Stop when the plaster forms 'islands' on the surface of the water.

4. Close the top of the food bag, whilst at the same time trying to get a bit of the air out of the bag. If possible tie a tight knot in the bag, or otherwise hold it closed tightly. Using your fingers, through the bag (rather than inside the mixture) gently agitate the ingredients so they are well mixed.

5. The plaster mix will take roughly 15 to 25 minutes to set. For the first five minutes or so you can leave the bag carefully on the side, BUT do not forget to come back for the next stage!

6. Just before the plaster starts to thicken, and holding the bag by the top to make sure it does not leak, gently move the bag around so that the mixture does not settle before it sets. You want to make sure the treasure is well distributed inside.

7. Stop agitating the bag just before the plaster starts to set. If you try to mix or press the setting plaster you will actually destroy its structure.

8. Once the plaster has fully set (it should have become warm and then cooled down), tear away the plaster bag.

9. Now you can carve your shape with a spoon and find your treasure! Use your spoon against the inside bowl shape of

the spoon so that you can add extra pressure. This stage is quite messy so make sure you carve over a bowl to catch the plaster crumbs.

10. Carve until the treasure begins to be revealed and you are left with a treasure embedded rock!

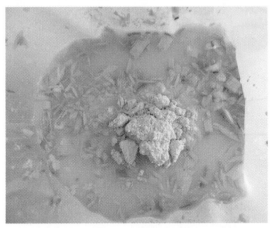

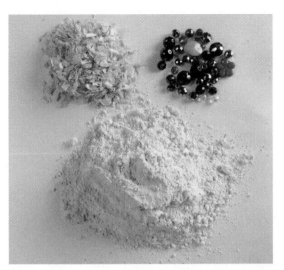

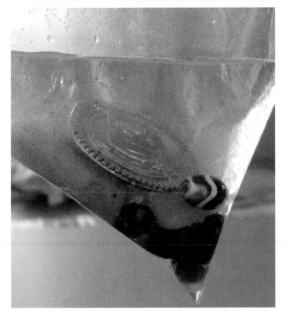

FACILITATOR'S NOTES

Make sure that the plaster is used in a safe manner in a well-ventilated area (p 24).

It may be appropriate to mix the plaster for young children, and then the children can help by combining the materials with their hands, through the bag once the bag is closed.

The sawdust acts to help keep moisture in the plaster making it easier to carve. Carve the rocks straight away (rather than leaving them for days), as the plaster will be much harder to carve when it is completely dry.

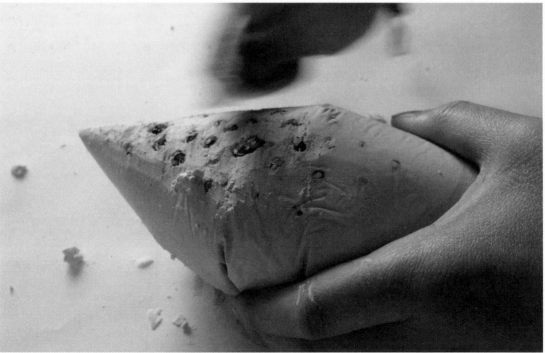

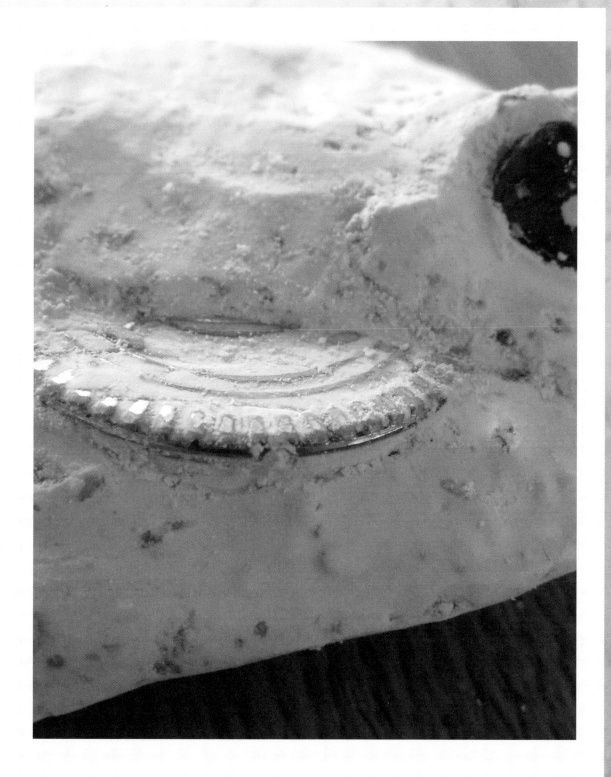

GLUE GUN CONSTRUCTION

Some of the most fun and inventive making sessions happen when you just have a pile of materials and a glue gun! You might not even have a theme or focus, but something always emerges.

MATERIALS AND EQUIPMENT

— A selection of found objects or materials
— A cold melt glue gun

ACTIVITY

1. The materials will be the source of your inspiration, so make sure you have a large selection to choose from and that you like what you see!

2. Do not worry if you cannot think of an idea when you start work—you soon will! Just begin by picking up materials and looking at their qualities: their colour, form, surface, personality....

3. Place materials next to each other. Does that help trigger a thought? Will your sculpture be something (ie an alien), or will it just be an exploration of the materials?

The great thing about glue guns is that they allow you to construct quickly (as the glue cools it sets), but most of the time if you do not like what you have done, you can take it apart again. Use the glue gun carefully (p 38), but enjoy the freedom it brings to your constructing.

5. Remember! When you make sculpture, things fall over and/or break. Just take a deep breath and keep going!

6. Be as inventive as you can and push the materials!

FACILITATOR'S NOTES

Glue guns should be used with care. Cold melt glue guns are suitable for use with children, under supervision. Never leave a glue gun plugged in for an extended period of time, and always explain a safe method of use to children before starting on a project (p 38).

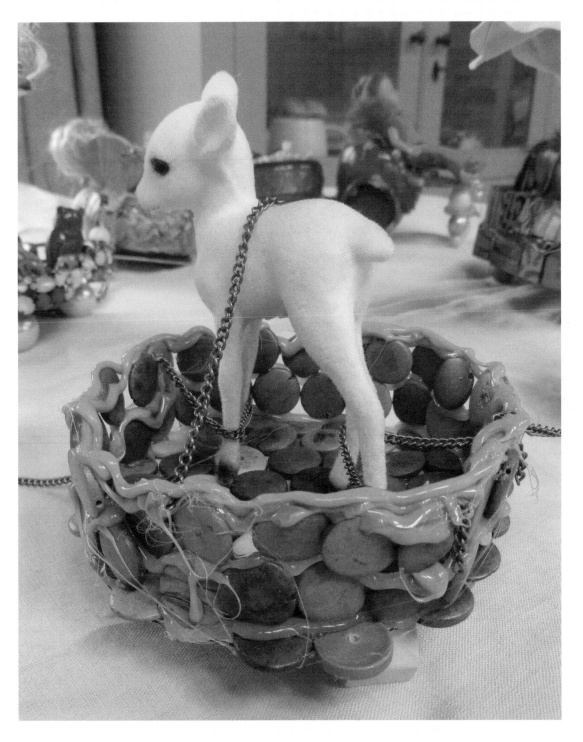

SUNKEN PIRATE SHIP

These pirate ships are great fun to make because they are simple, yet look more complex. Taking the mould away to reveal your masterpiece will be the best part!

MATERIALS AND EQUIPMENT

— Foam print board
— Carton closure tape
— Plaster
— Old jewellery
— Sticks
— Fabric
— Scissors
— Bucket

ACTIVITY

1. Make a very simple boat shape mould similar to the template on page 60. Copy the three shapes onto pieces of foam print board and cut them out. Fasten the mould together with carton closure tape, taking care to ensure all pieces are fastened securely together to avoid leaks. Make sure the tape is only on the outside of the boat mould!

2. Wedge your mould in a small bucket or plastic pot.

3. Choose some old jewellery and drape it inside the mould, making sure that at least some of the pieces are in close contact with the foam print board. Let some pieces drape over the outside.

4. Make a flag out of fabric and attach it to a stick. See if you can position the stick (the flagpole) inside the boat mould. You can use small bits of tape to keep it in place.

5. When you are ready, mix your plaster (p 24) and slowly pour it into your mould. Make sure your flagpole remains upright. You will have a little time before the plaster sets to push the jewellery towards the edges of the mould.

6. Once the plaster has set, you can carefully pull away the tape and take apart the mould to reveal the jewel embedded plaster ship!

7. Your final challenge is to help the pirate ship stand upright, or maybe you would prefer it to slump to one side! Think which objects or materials you might use to make a context for the sunken pirate ship.

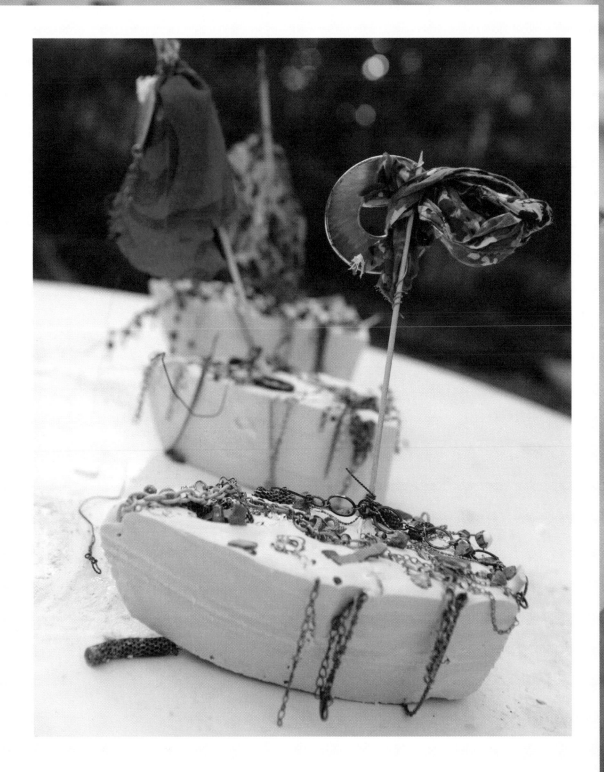

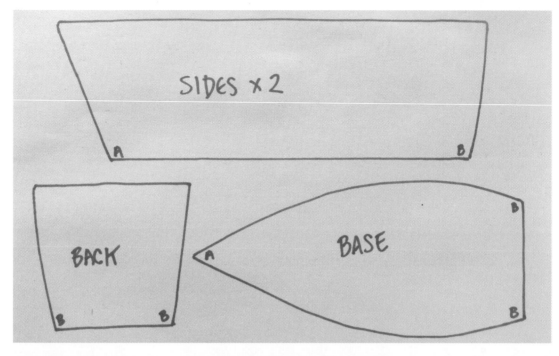

SIDES x 2

A B

BACK A BASE B

B B B

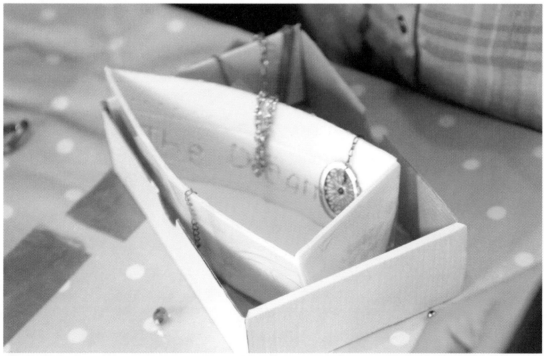

CONSTRUCTED FISH AND GYOTAKU

Lots of fun is involved in making these constructed fish that are then decorated with printmaking!

MATERIALS AND EQUIPMENT

— Black plastic bin bag
— Masking tape
— Modroc
— Scissors
— A fresh fish (something a similar size to your sculpture)
— Thin, newsprint quality paper
— Paper towel
— Acrylic paint
— Brushes
— PVA glue

ACTIVITY

Making the Fish

1. Take a black bin bag. Start by rolling up the bin bag, rolling from the shorter end.

2. Continue rolling until you reach the middle of the bag. At this point, pull the edges of the bin bag towards the centre as you roll. This helps give shape to the 'tummy' of the fish.

3. Keep rolling until all of the bag is rolled up and then secure with tape. The firmer you roll the bag, the smaller the fish and the more solid the sculpture will be. At this stage the sculpture should look a little like a straight croissant.

4. To make the tail, squeeze in the 'waist' and secure with tape. At the same time, fan out the end of the bag in a tail shape.

5. To make the nose, decide how long you want the fish to be. If your fish is too long, fold back the very end of the fish, squeeze it into a snout shape, and tape it down.

6. Add extra tape to any areas that feel less than secure, and use the tape as a modelling material to 'pull' any of the form into shape.

7. Once you are happy with the fish shape you are ready to cover the plastic in modroc. Use the modroc as described on page 28 and work until you have covered the entire fish in four or five layers. Put the fish aside to dry.

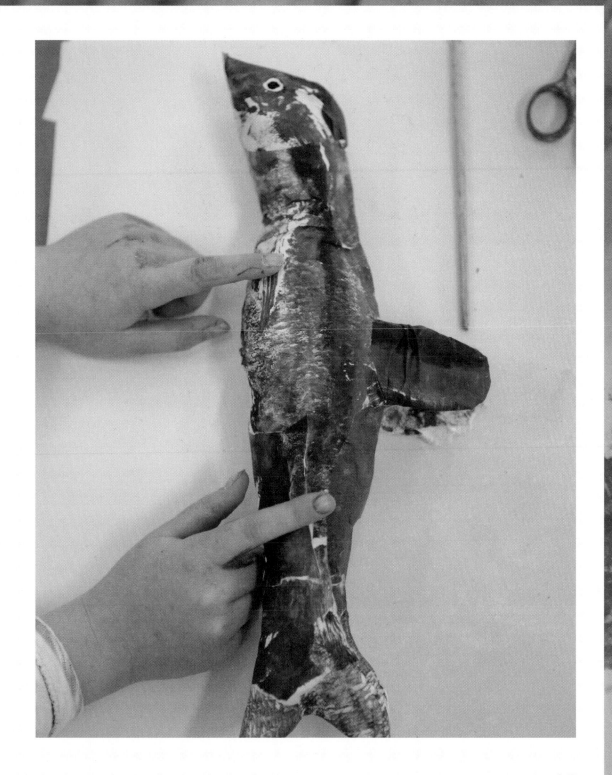

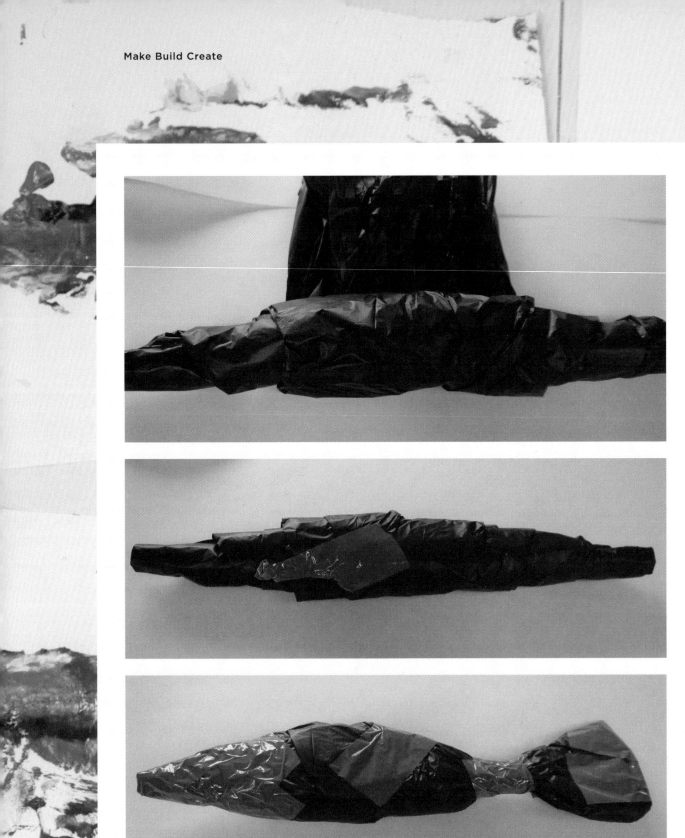

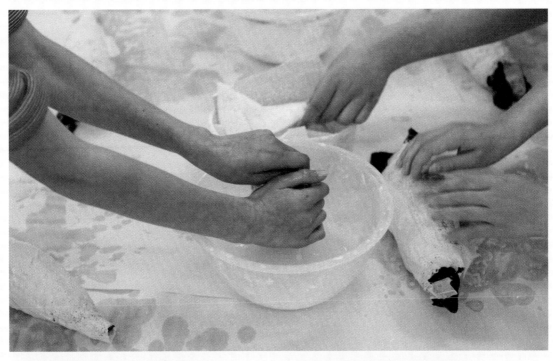

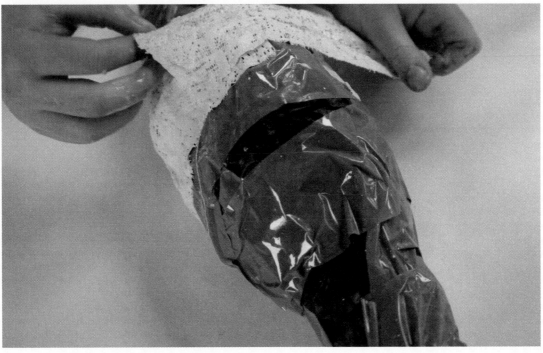

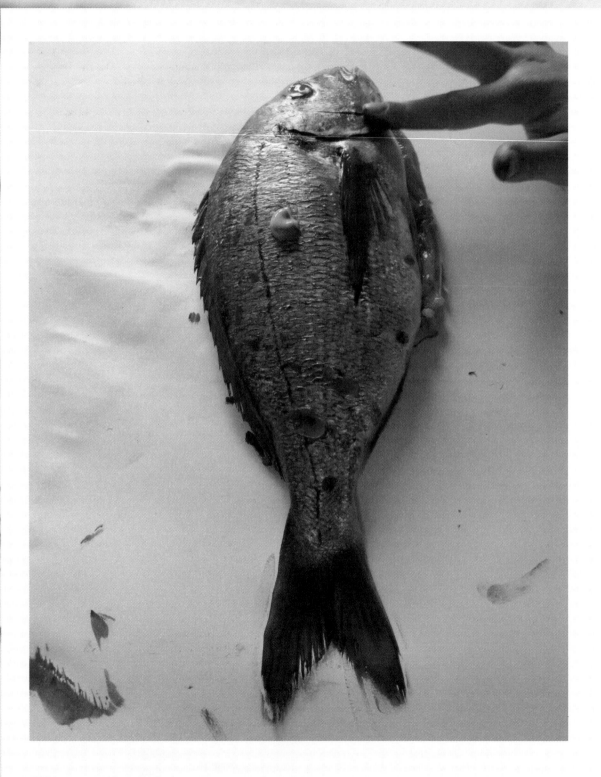

Decorating the Fish

1. Next you will try your hand at the ancient Japanese art of Gyotaku and then use your print to collage over the fish sculpture.

2. Take a fresh fish and use a paper towel to pat it dry and remove any slime.

3. Use a brush to apply a thin layer of paint across the fish, taking care to adequately cover fins, etc.

4. With clean hands, lay the thin sheet of paper over the fish. Use your hands to gently but firmly push the paper over the fish, working in the direction of the scales. Work your fingers evenly around the entire fish, making sure the paper makes contact with all areas of the fish.

5. Gently pull back the paper to reveal your Gyotaku print!

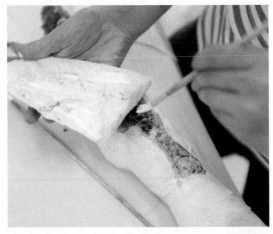

6. Once the print is dry, cut it out, and then apply a thin layer of PVA glue to the fish sculpture. Carefully lower the fish print over the sculpture and apply pressure with your fingers to collage the print to the modroc.

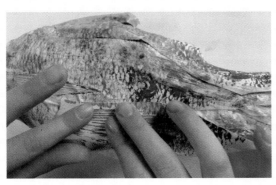

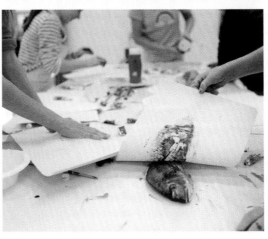

CASTING AN EGG

Look around you and you will see lots of things that have been made in a cast. That is to say a mould has been made of an original object that then allows the manufacturer to produce many more copies of that original object. Sculptors have used this method for many years too, to transform an object from one material to another. Follow the steps in this project and you will have first-hand experience of how to make a mould and take a cast!

MATERIALS AND EQUIPMENT

— School clay
— Modroc
— Plaster
— Washing up liquid or petroleum jelly
— Buckets
— Water
— Protective sheet
— Dust mask

ACTIVITY

1. Make a simple clay egg shape. Aim for the egg to be about 15 to 20 cm/ 6 to 8 in tall.

2. Make thick clay sausages and press them flat. These clay sausages will be used to make the walls of the mould. Aim for these to be about 2 x 1 x 20 cm/ $^3/_4$ x $^3/_8$ x 8 in.

3. Imagine a line running around the egg shape, which splits the egg into two equal halves. Place the clay sausage along this imaginary line. Do not join the clay sausage to the egg; just let it rest firmly. The clay sausage will act as a 'wall' against which you cast the first half of your mould.

4. Using strips of modroc cover one half of the egg. Make sure the first layer of modroc is in close contact to the egg and the wall. Press the modroc firmly against the clay and smooth it well.

Tip: Normally a plaster mould is made with fine casting plaster. Fine casting plaster picks up all the detail in the clay original. Here, for simplicity and to contain the mess, we are using modroc to make the mould. This will pick up less detail, but you can pick up as much detail as possible by making sure the modroc is pressed firmly against the egg.

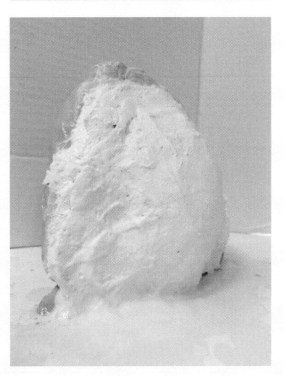

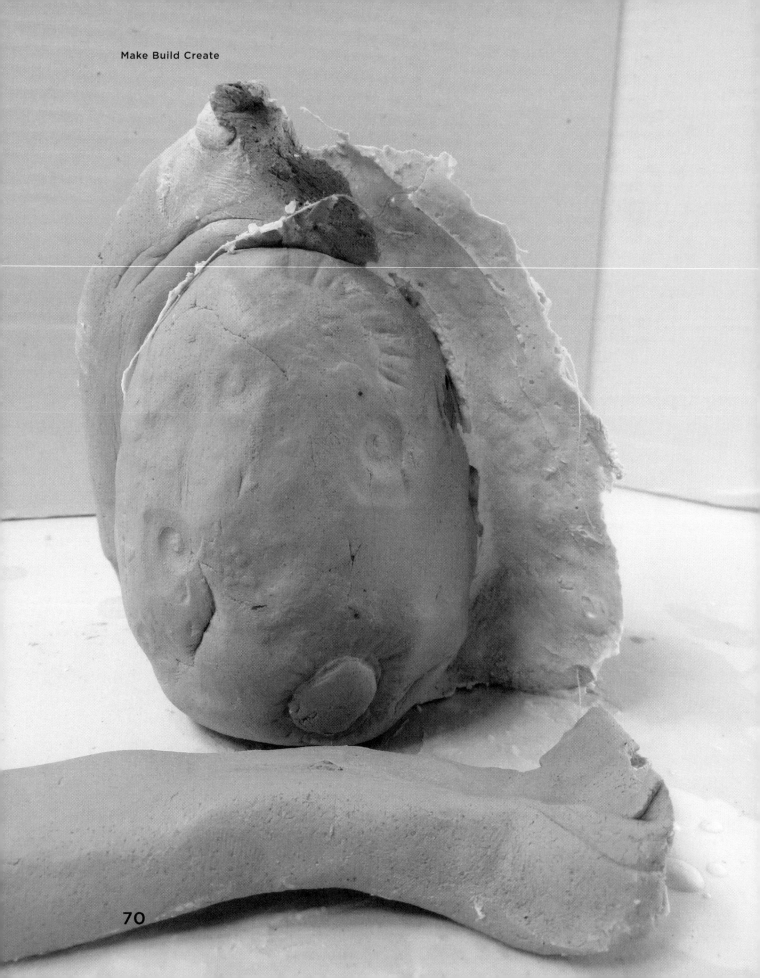

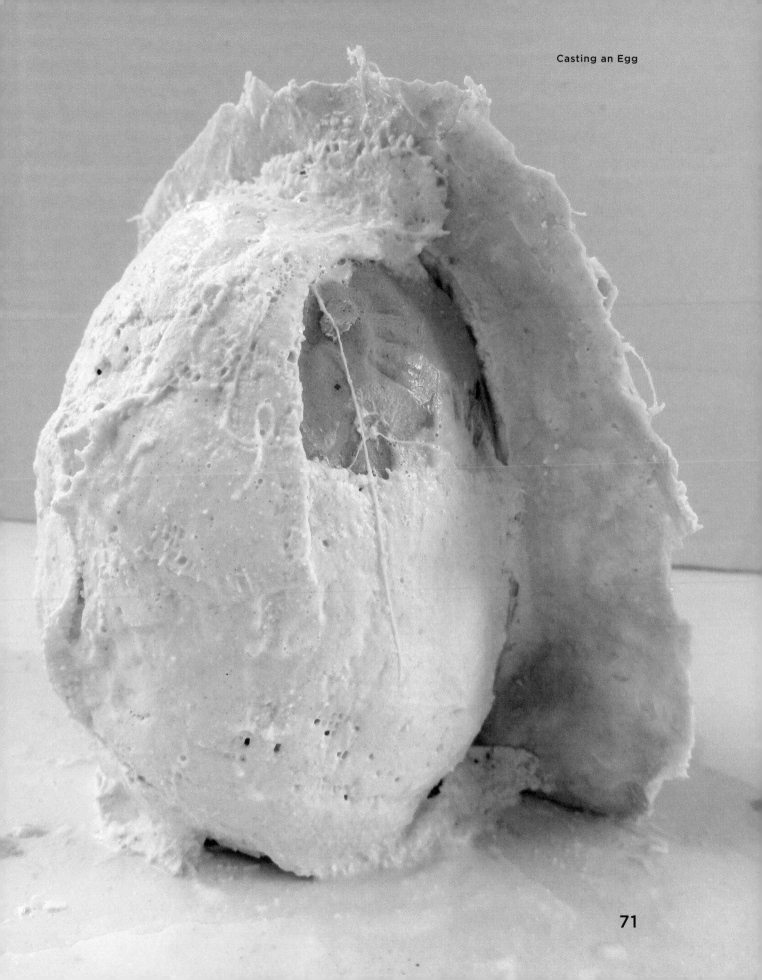

Make sure you cover with at least six layers of modroc. Once set, this will create a hard, strong shell.

5. Once the first half of the mould is set, remove the clay wall. Take care to make sure the first half of the mould remains in place.

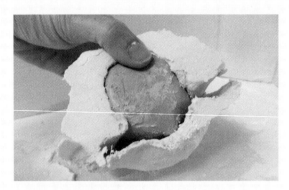

6. Apply neat washing up liquid or petroleum jelly to the edge of the first piece of mould. This will act as a barrier so that when you open the cast the two plaster halves come apart. Do not forget this stage!

7. Repeat the modroc process on the second side so that you have covered the entire clay egg. Take care not to let the modroc wrap over the first half of the mould. Allow to set.

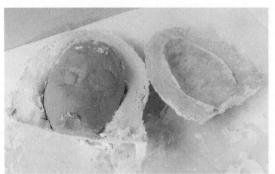

8. Once the modroc is set, lift the mould away from the base and you will see the clay egg inside.

9. Using your thumbs gently force the two halves apart and remove the clay egg.

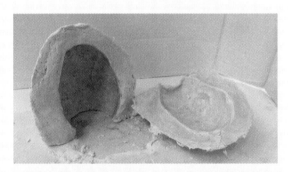

10. Repeat the process with the washing up liquid or petroleum jelly over all interior surfaces of the mould. If you use petroleum jelly rub it well into the plaster.

11. Place the mould back together and secure with rubber bands, making sure that the two halves fit snuggly (so you have no leaks), and that the rubber bands are tight. Place the mould upside down in a bowl to catch any leaks.

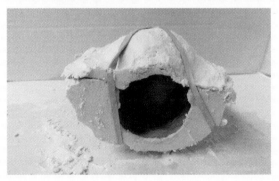

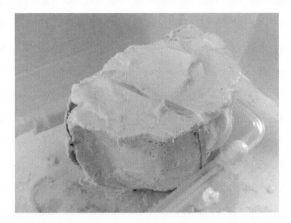

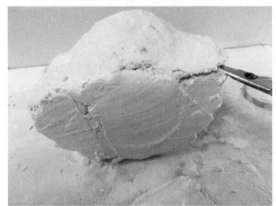

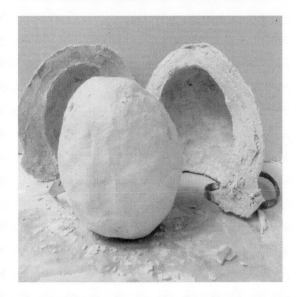

12. Mix the fine casting plaster (p 24) and pour into the mould. Have a small amount of clay ready to block any leaks!

13. Once the plaster is set, remove the bands and use the end of a pair of scissors facing away from you to gently open the mould.

14. The cast is revealed. The seam around the egg can be filed away with a spoon whilst the plaster is still wet and the end of the egg that was cast against the table can also be shaped.

15. You have transformed your egg, and if you are lucky, you can use the mould again to cast more!

FACILITATOR'S NOTES

Casting is a defined process that takes time but can be very empowering. By starting with a very simple shape such as an egg, the process can be simplified into a two-piece mould. However once the technique is mastered, the shapes can become more complicated using two, three and four piece moulds, such as the chair on page 129.

See using plaster and using modroc (pp 24, 28).

WHAT NEXT?

Once the plaster eggs have been cast, think how these might be further transformed!

BE LIKE A BIRD

... and make a nest! Enjoy drawing and constructing and explore making spaces which feel 'safe'.

MATERIALS AND EQUIPMENT

— Graphite and hard (H) pencils
— Drawing paper
— Watercolours
— Wax crayons or candle stubs
— Brushes and water
— Eraser
— Clay
— Sticks, twigs and string
— Your hands!
— If possible: an abandoned nest, or if not, images of nests

ACTIVITY

1. First of all, get a sense of a concave shape by cupping your hands into a bowl shape. Think of your hands as a potential nest, creating a safe space. Hold your hands over a sheet of paper, and imagine the nest shape drawn upon it. Your challenge will be to turn 'paper' into 'nest'.

2. Using either a picture of a nest, or an abandoned nest as subject matter, make a drawing of a nest, trying your best to capture the concave shape. Take a hard (H), sharp pencil and hold it lightly. Make light, skittish, repeated marks across your page to gradually build an image of a fine, delicate nest.

3. On another sheet of paper, make another image of a nest, this time using chunky soft graphite sticks, wax resist and watercolours. This time try to make your marks as dark as possible to create a dense, messy nest. Use layers of wax resist before the watercolours, and use the eraser to knock back the graphite. Add energy into the image by drawing from your shoulder rather than your wrist. Experiment with how the layers build to make the nest. As you draw, keep thinking of the concave, safe shape you are trying to draw.

4. Now it is time to make a nest! Experiment with how you can build a concave shape from the clay, using the shapes of your hand (palms, backs, fingers, as tools). How can you embed other materials such as twigs, sticks and string? Where will the entrance to your nest be, and how open or closed is the structure? Will the nest grow from the floor or be balanced in branches? Will it be a delicate, fragile

nest, or something more robust? Will you add material (additive sculpture) or take away material (subtractive sculpture)? Or both?

5. Enjoy the way the drawing feeds into the making, and the making feeds into the drawing. You could even try drawing a nest using smudged wet clay and sticks! Or how about building your nest in the low down branches of a tree!

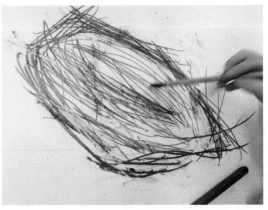

FACILITATOR'S NOTES

This project gives children the opportunity to both draw and make, and to experience the relationship between the two. You may like to begin the session with a quick discussion about the nature of nests: 'safe' yet often fragile places, a record of the many repeated actions that turn chaos into order.

If you are working with many children, create three different workstations, introduce all activities at the beginning and then let the children move between the activities independently, in any order.

I also introduced a rule for this session: that we would concentrate on the nests, and not imagine chicks and eggs! Sometimes it is helpful to be explicit about expectations to help children concentrate on the themes for the session.

LIFE-SIZED PETS

This project involves lots of great skills: drawing, seeing negative space, scaling up, collaging, construction, balancing.... Take it stage by stage and you will have created a sculptural pet you can be very proud of!

MATERIALS AND EQUIPMENT

— Corrugated cardboard
— A4 paper
— Pencils
— Marker pens
— Rulers
— Scissors
— Photocopies for collage
— Glue stick
— Strong tape
— Craft knife

ACTIVITY

Scaling-up the drawing

1. The first stage is to scale-up a drawing. This is a traditional drawing technique and useful to know.

2. Take a simple image of an animal (eg a dog) on an A4/8½ x 11 in sheet of paper. You are really only interested in the outline. Use a pencil and ruler to draw a simple grid over the animal. A 4 x 4 grid should be just right.

3. Next take a sheet of cardboard and draw another grid over this. This time, making sure you draw the same number of squares, make it so each square is much larger. This is how you will scale-up your work. If you need to, join two sheets of cardboard together.

4. Now, taking a pencil and working one square at a time on the larger grid, copy the line that dissects each square on the A4/8½ x 11 in sheet of paper. If you have a complicated shape in a particular square, you can always further dissect that square to help you see the relationship and placement of lines. When you are looking at each square and trying to decide the shape of the line, try to look at the space around the dog as well as the dog itself (this is called seeing the negative space).

5. Keep working one square at a time to scale-up your drawing and your animal will slowly appear on the larger piece of card. Keep standing back however and try to see your animal as a whole to help spot errors.

6. Once you are happy, use a black marker pen to go over the lines.

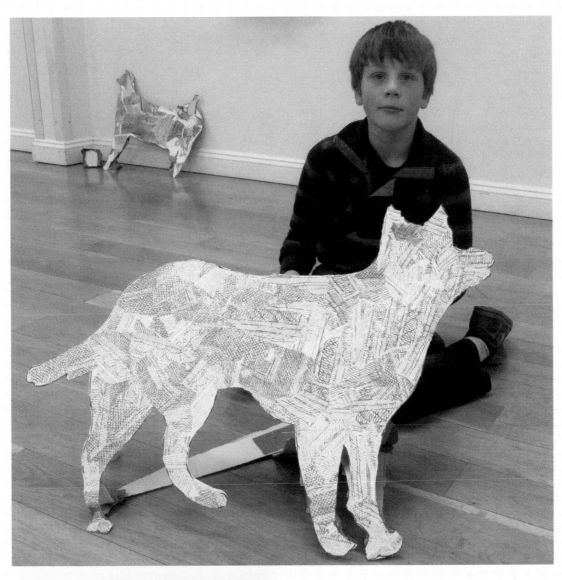

7. Ask an adult to cut out the animal, using a sharp craft knife. You will then have a scaled-up life-size (or even larger) pet. Next step, collage and construction!

Collage and Construction

1. Consider how you might like to decorate your pet. In this example we used photocopies of old etchings to create a series of sheets with exciting marks on them, and then used these sheets to collage over the cardboard pet.

2. Tear and cut the sheets of paper to create texture, and use the glue stick to firmly glue each piece down. You might like to add drawn marks using your marker pen over the top of the collaged sheets to help add definition and features to your pet.

3. Once the collage is finished, your next challenge is to make your pet stand! Use cardboard and strong tape to make a stand at the back of the sculpture. Use a combination of triangles to help make the stand strong. If the sculpture falls backwards or forwards, think how you need to modify the structure to help it stand. This is where you need to think like a sculptor! If it falls over, persevere, as you will get there! You could also think how you might use pet toys or food bowls to help the sculpture stand.

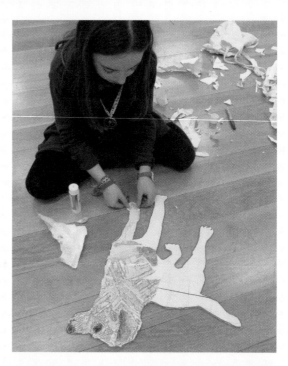

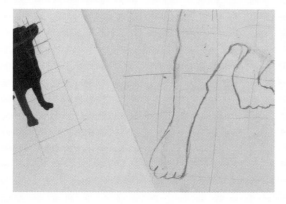

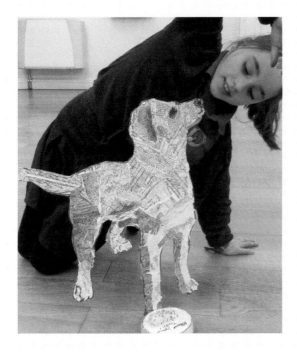

FACILITATOR'S NOTES

This project encompasses many skills all of which work together to create a final outcome. Splitting the project into its parts, with time to explore each, is important to its success.

Prior to the session consider making a simple jigsaw from foam board using the silhouette of dog. Purposely leave the positive shape white and make the negative space around the dog a (positive) colour. Without showing the children the white piece, lay out the negative shapes, asking the children to shout out as soon as they think they know what it is. Of course at first the children will be looking at the negative pieces as positive shapes and find it hard to recognise a "dog".

Seeing and drawing negative shapes helps us to make more accurate images as our brains are less familiar with negative shapes, so we allow ourselves to really look at their shape. We tend not to try and guess negative shapes as much as we tend to guess positive shapes. Using both negative and positive shapes can really help our drawing skills.

Provide the children with some really simple, but instantly recognisable images of pets in silhouette, perfect for seeing negative/positive space. When you try to see negative and positive shapes you have to flatten an image in your mind, and using silhouettes helps children do this.

You can also make some simple small square templates that the children can use to draw a grid over the pet images. This is a simpler way than to ask children to measure the grid with a ruler.

Dealing with mistakes in a grid drawing

— Tackle a mistake head on as soon as you spot it, rather than hide from it!
— Use light pencil lines until you are sure of the lines.
— Rub out any mistake areas before they become entrenched and affect the rest of the drawing.
— Use a square of paper over the top of the 'mistake' square and then re-see/re-draw the shapes. Then you can lift up the square of paper and compare and contrast the two versions, before tackling them on the card sheet.

MODROC POLAR BEARS

MATERIALS AND EQUIPMENT

— Old plastic bags
— Newspaper
— Masking tape
— Modroc
— Scissors
— Paint (poster paint or acrylic)

ACTIVITY

1. Before you make your sculptural polar bear, take a moment or two to make sure you know what polar bears look like. This might be through watching a film of polar bears, making a drawing of polar bears, talking about polar bears or even just looking at still images. Whichever way you familiarise yourself, try to become aware of the big shapes which make up a bear, the way a polar bear walks, the areas of the polar bear which are comparatively fine (maybe its claws and nose), where its eyes sit within the face, how the skin and muscle frame the bones. All of these characteristics will help inform your sculpture and help to create a sculpture with personality!

2. To begin to make your polar bear, take a number of old plastic carrier bags, or old newspaper. You might prefer to use old plastic bags as they can bring roundness to the finished sculpture.

3. The idea is to build a rough polar bear shape out of plastic, paper and tape. This is called the armature. Start by simply scrunching the bags or paper in your hand. Do not worry if you are unsure as to what you are doing—just look to the forms in your hands for clues. It may help to have an area of the polar bear in mind as a starting point. For instance that nice big muscle at the back of the neck, or its lovely rounded bottom. See the big shapes and just scrunch the material, and when you see a shape you like, tape it in place to stop the plastic or paper unravelling.

4. Keep adding more plastic or paper to keep building the shape. Remember the whole thing will be wrapped in modroc and at that stage you can add finer detail. Remember too that you are building a three-dimensional object so keep turning the polar bear and checking its progress from all angles.

5. Make legs from more plastic or paper, but when you add them to the body, try using even more plastic or paper to act as connective muscle. The legs need to feel a part of the polar bear, not just tubes that stick off the body.

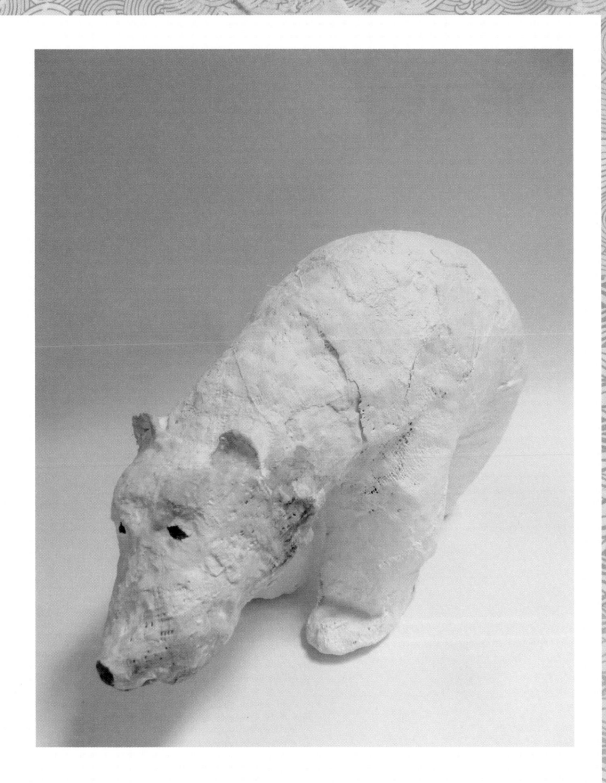

6. While you are making, keep thinking about those polar bear characteristics. Think also about how your bear will stand. It can often make your sculpture more interesting to add a twist to the body or head to take it away from the symmetrical.

7. Keep taping the plastic or paper in place as you go. The whole armature needs to be strong to support the next stage.

8. Now you can cover the armature in modroc! Use the modroc according to the instructions on page 28. Make sure you use your fingers and hands to smooth over the modroc. Use large sheets to make the sculpture stronger, and use smaller pieces to add modelled detail such as ears, noses and claws.

9. Once the modroc is set you can then paint your sculptures. Again take a look at images of polar bears to be sure what kinds of colours you might use, and don't just assume polar bears are white!

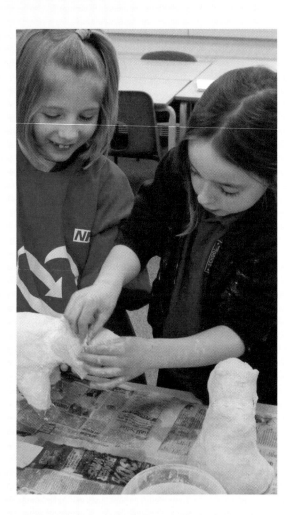

FACILITATOR'S NOTES

The construction stage of this project will be energetic, messy and a noisy session as children battle with the materials to create their forms. With small groups consider enabling children to work on the floor in an inward facing circle with the materials in the middle. There is always lots of chatter (and frustration) but working in a circle like this helps children to focus, and to become aware of what others are doing, which in itself helps the making process.

At the modroc stage, as facilitator, there is also the opportunity to address any structural problems with polar bears that are struggling to stand. Small amounts of modroc can be added to any legs that are maybe a little short.

WHAT NEXT?

Make some sheets of home-made plasterboard (p 48) and build your polar bears an iceberg!

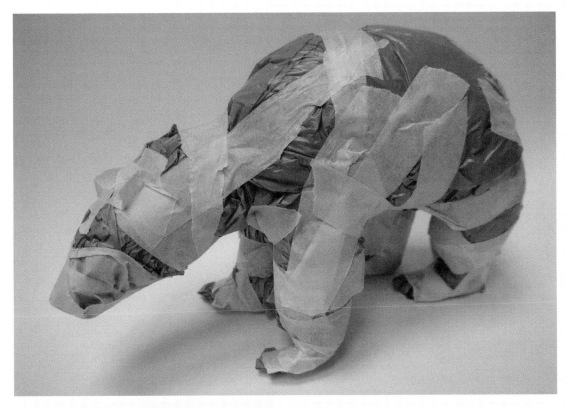

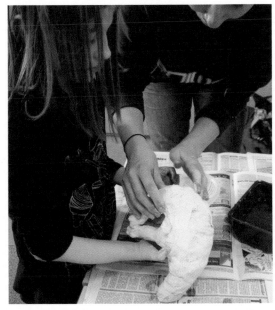

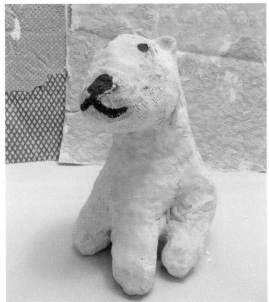

WIRE INSECTS

Working with wire can be tricky, but this project enables you to make fantastic and imaginative creatures in stages. Start yourself an insect factory!

MATERIALS AND EQUIPMENT

— 0.75 mm/ $\frac{1}{32}$ in iron wire or similar
— Feathers and fabric
— Long-nosed pliers

ACTIVITY

1. You might want to use a book or the web to explore and be inspired by the anatomy of insects. Take a look at the shapes of their legs, antennas, thorax, forewing, hindwing and abdomen. Enjoy the variations, and imagine what kind of an insect you might make if you "took a bit of this, a bit of that...".

2. Begin working with the wire. Cut off a section of wire (generally longer than you think you may need), and begin to twist it into a shape. The aim is just to make one section of the insect at a time, for example a leg or an antenna. Have fun, be inventive and see where the wire takes you. Make a selection of body parts so you have plenty to choose from.

3. Use the long-nosed pliers to help you bend the wire into shape. The pliers will give you far more control than your fingers alone and you will be able to make more precise shapes.

4. Explore how you can use fabric, feathers and fur in combination with the wire. Cut small pieces of material, curl them up and wrap them with wire.

5. Once you have an exciting selection, begin to assemble the pieces one at a time to make your hybrid insect. Use new pieces of wire to fasten one or more body parts together. Poke the wire through any holes in the body parts that will allow you to fasten pieces together and bind tightly (again using the nose of the pliers to help you pull the wire tight) to secure. Use longer pieces of wire than you initially think. This will make it easier to bind tightly and you can always cut off the extra wire at the end.

6. As you work, keep checking how your insects stand. You can easily help these sculptures stand by twisting a leg or changing the position of a wing. Or hang them and let them fly!

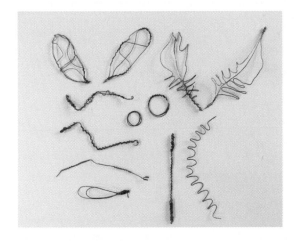

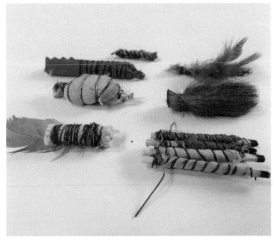

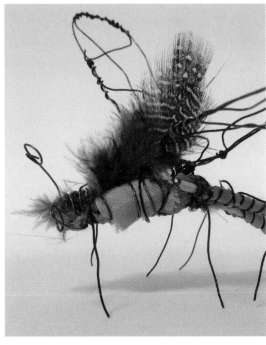

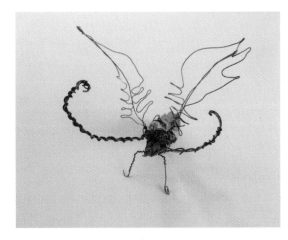

FACILITATOR'S NOTES

Try to encourage children to work with the pliers in their hands, holding the wire in their non-dominant hand and using the pliers to bend the wire accurately as an extension to their hand. After a while, it will become second nature; much easier and more effective than continuously "picking-up, putting-down".

Top Tip!

When joining two pieces of wire, always start in the middle of the wire rather than from one end. This way you have longer pieces of wire to twist, which makes it so much easier to get a tight connection.

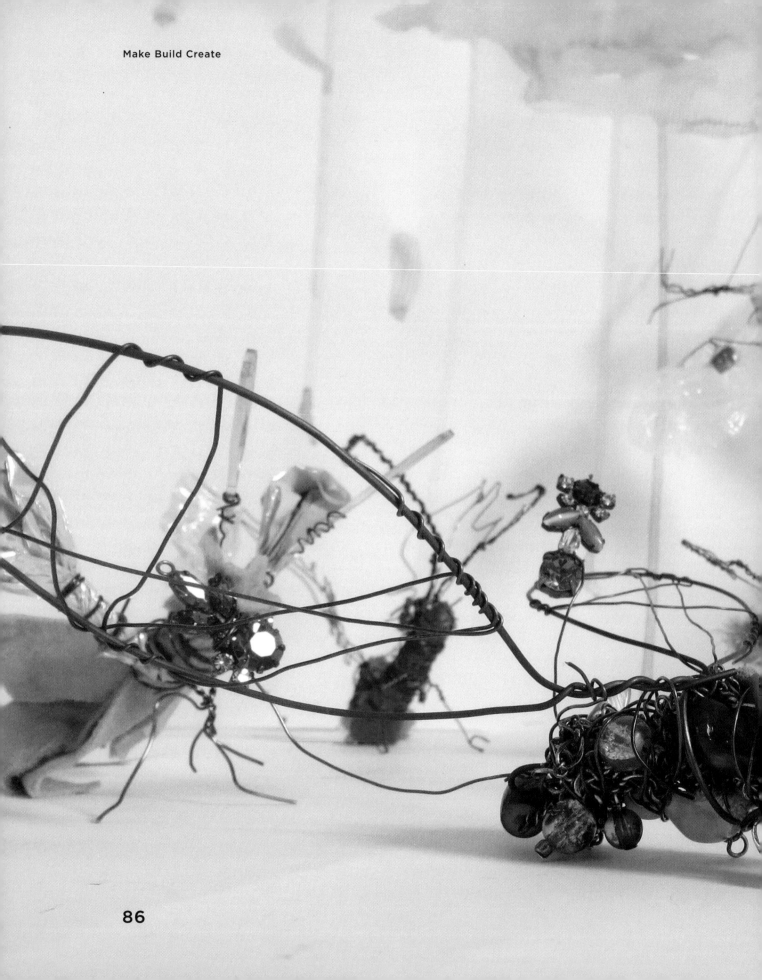

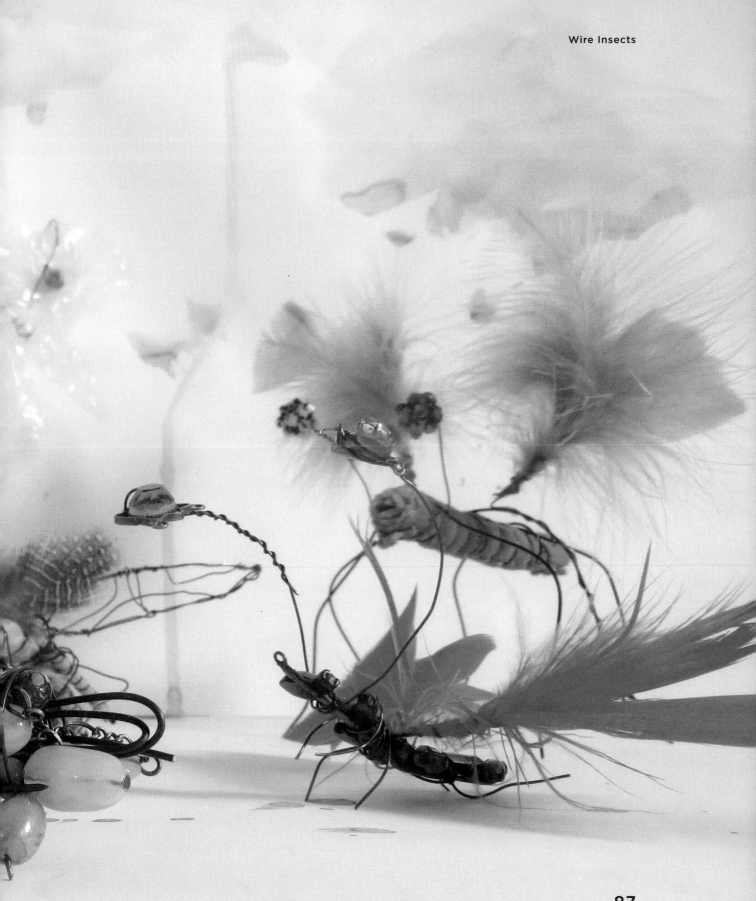

QUICK CLAY FIGURATIVE SKETCHES

Enjoy the freedom of making quick sculptural sketches out of clay. In this project, you will take your inspiration from a gallery setting, and make figurative sculptures in response to a sculptural centrepiece.

MATERIALS AND EQUIPMENT

— School grade clay (resist using air dry clay which is slightly harder to model with)
— Building bricks or wooden blocks
— Small pieces of cardboard
— Clay tools
— An object which can be used as a 'sculpture' to inspire the figurative sketches

ACTIVITY

1. Begin by choosing an object that will act as a sculpture to inspire your figures. This might be an existing object such as a large book or vase, or it might be something you have made. The clue is to choose an object which is about 30 cm/ 12 in tall, and that you can imagine your clay figures reacting to in some way. Put the sculpture in the middle of the room.

2. Time to use your imagination! Imagine you are only 15 cm/6 in or so high, and you are looking at the sculpture in a gallery space. How do you act? Do you sit, look and think? Do you walk around the sculpture? Do you talk to your friend about it? How are your feelings about the sculpture reflected in your pose? You might even want to get into the poses and see how they feel.

3. Take a small lump of clay and a piece of cardboard. If you want to make a seated figure, take a building block to use as a seat. Thinking about the physicality of the pose, make a clay sketch that captures your reaction to the sculpture. Work quickly: it should only take ten or 20 minutes to make your clay sketch. Focus on the big shapes. Add detail only to add character and definition.

4. When your figure is finished, position it near the central sculpture and enjoy the relationship between the two, as the gallery space and the clay visitors emerge.

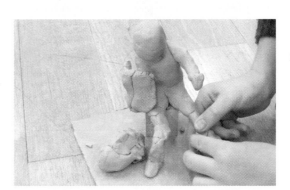

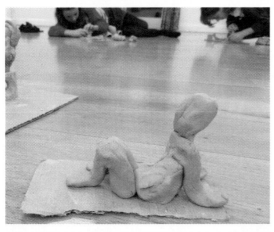

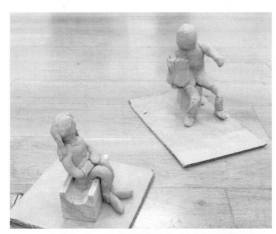

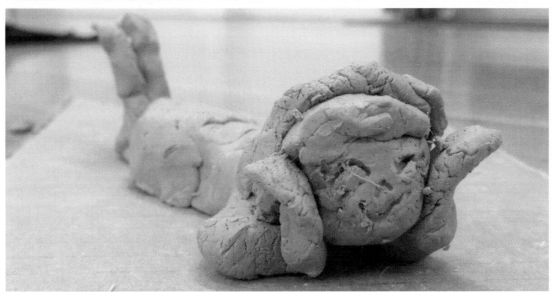

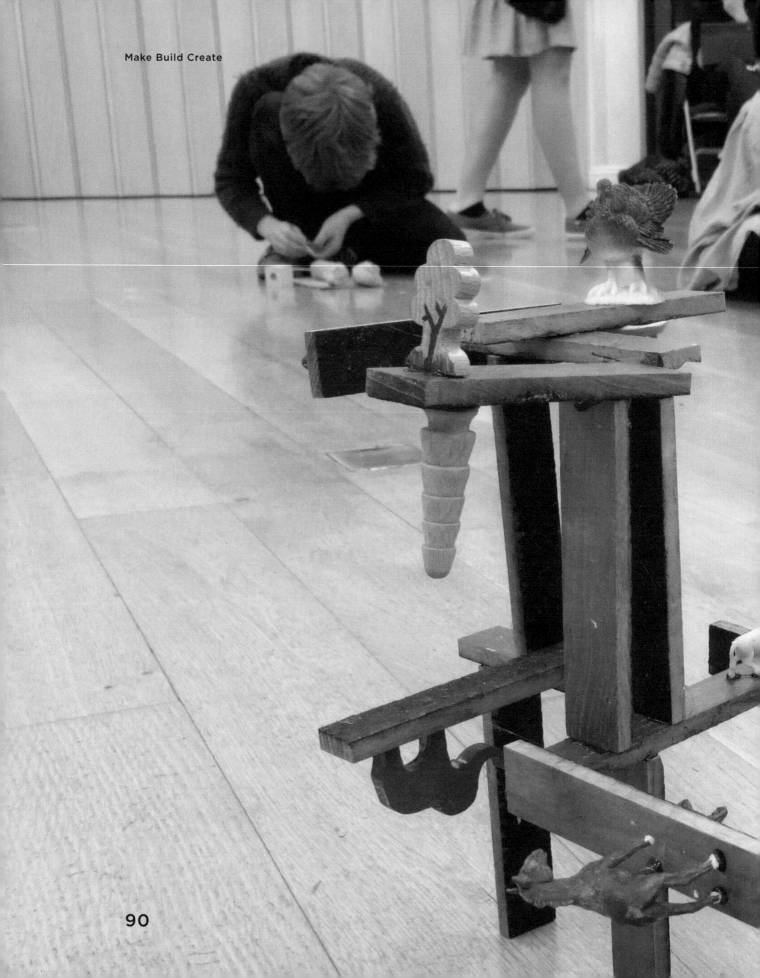

FACILITATOR'S NOTES

In particular I wanted this project to enable children to experience:

— How working with clay can be tough on little fingers—you need strength in your fingers to manipulate the clay. Making sculpture is all about manipulating materials (transforming the materials of the world), and sometimes this can be hard work! But that is okay... don't give up!

— How working quickly and intuitively (without worrying about the permanence of the end result) can free the children up to enjoy the journey and learn about form along the way. "We know the clay will finally crumble and break if it's not fired, and that the sculptures will cease to exist, but we'll have photos, and you'll have had the experience, so let's enjoy the process!"

— How they can make sculpture in response to an object. Using empathy as an inspiration.

— Different ways of gathering information to help inform their sculptures. The children can decide which ways they use:

— Sight: What does the pose look like?

— Knowledge: What does it feel like to be in that pose?

— Can you think of any other ways?

— To look for clues in the shapes they make, which might help them develop the sculpture further. For example, does that piece of clay remind you of an elbow? In what position? How can you build on that?

— To explore how much detail you need, or not, to enable your sculpture to communicate? Does it matter if the leg is a sausage? Can a nose alone help communicate the mood of a face?

Without being fired, the dry clay has a limited lifespan, and the sculptures will crumble, but I think it's important to remind ourselves that even without access to a kiln, clay can still be regarded as a valuable sculptural material.

It's worth noting, for teachers who need to control mess, that when children use clay without extra water (you would need water to create a 'slip' to act as glue if you were joining pieces permanently for firing), that clay is not a particularly messy material.

Watch out for the small pieces of clay which dry out quickly and can easily turn to dust if trodden on, but otherwise working with clay does not have to be a messy business.

RELAXED SCULPTURES

Your challenge is simple: to create a figurative sculpture in a reclining (or relaxed!) position, using any of the available materials.

MATERIALS AND EQUIPMENT

— Cardboard or pieces of wood to act as bases or stool tops
— A selection of pieces of wood including canes, withies (willow sticks) and sticks
— A selection of wire
— Other construction materials including paper and fabric
— Pliers
— Hacksaws
— Cold melt glue guns and pellets

ACTIVITY

1. Before you begin making, take a moment to inhabit the pose you are going to make. That means get into position and see how it feels to be in that pose. Where are the stresses of the pose (where can you feel contact with the world, or where can you feel your body working hard?), and where do you feel is the strength of the pose? Combine this knowledge with how it looks to be in this pose (ask a friend or partner to take up the pose).

In particular look out for triangles made by parts of your body (spaces between arms and body maybe, or bent legs). Look for strong shapes, and let all this knowledge inform your sculpture.

2. To give yourself the chance to become familiar with the tools without worrying too much about your sculpture, begin by making a stool or platform for your reclining figure to sit on. Practice using the saw by cutting some sticks to length for the stool legs and practice using the glue gun by attaching the legs to the stool base.

3. When you are ready to start work on the reclining figure, think in terms of the big, gestural lines of the pose. You might choose to start work at the point where your sculpture touches the ground or the base, for example the way the bottom sits on the stool. Then you can work down the legs to the feet, and back up from the bottom, up the torso and to the arms. This way your sculpture will feel seated or rested. Experiment with using small bundles of sticks to create these lines securing them with wire and the glue gun.

4. Every now and then get back into the pose to check you have the feel of it. Look at your sculpture as it grows from

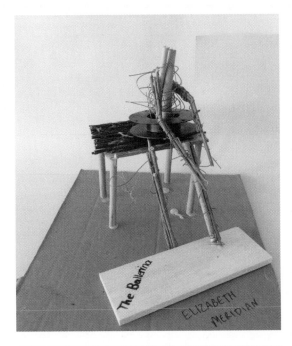

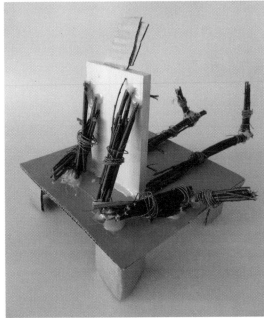

feel you should exaggerate to help tell the story of the pose. And do not assume your sculpture needs every part of a body to tell a story—fingers and head may be crucial, or not at all important!

5. Feel free to have fun at the end by making props that help tell the story. For example a book for a figure reading on a beach, or a television set for a person slumped in the lounge.

FACILITATOR'S NOTES

The aim of this project is to give children an opportunity to explore construction-based sculpture using both tools and materials. These tools include pliers, glue guns and hacksaws, all of which need to be used sensibly and with care (pp 36, 38, 40).

This workshop introduces basic sculptural ideas and vocabulary.

The session might begin with an introduction to sculpture designed to open minds and establish a baseline of understanding from which the children can then build on throughout the session. This might be achieved via a series of questions:

— What does the word "sculpture" mean to you?
— How large or small might sculpture be?
— What is sculpture made out of?
— What is special about making sculpture, compared to painting or drawing?
— What is figurative sculpture?

all angles. You are in control, so you decide if there are bits of the body you

SHOE TRANSFORMATION

You will never look at a shoe the same way again after this project. Transform the look, feel and form of an old shoe into something much more interesting!

MATERIALS AND EQUIPMENT

— An old shoe
— Modroc
— Scissors
— Wire, wood and fabric
— Cardboard
— Tape
— Paint
— PVA glue
— Additional found or decorative objects

ACTIVITY

1. Begin by taking a good look at your chosen shoe. Your challenge is to transform the shoe into an object with personality. You might decide to create a different kind of shoe, for example, transforming a sandal into a boot. Or you might prefer to leave the 'shoeness' behind and instead create a whole new object....

2. Do you want to cut into your shoe to change its form? Get an adult to help you if the shoe is made from a tough material.

3. Do you want to add materials to change its form? Use wire and pieces of wood, or more fabric, to change the shape.

4. You can try using cardboard to add a heel or to further change the shape of the shoe. Tape the cardboard in place. The whole thing will be covered in modroc in the next step so any method of fastening need only be temporary.

5. Once you are happy with the new form, cover the entire shoe with modroc (p 28).

6. Once the modroc is dry, you can paint it with any water-based paint. You can also use PVA glue to add material or paper, or use more modroc to embed or attach any objects such as beads or feathers.

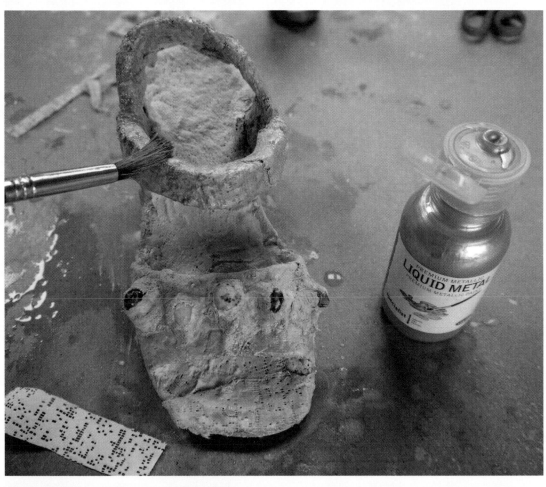

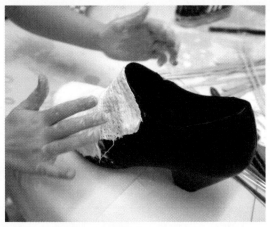

LIFE-SIZED FASHION

Work alone or as part of a team to create life-sized sculptural fashion. Without ever having to actually wear the sculpture, see how far you can push the paper and the figurative form!

MATERIALS AND EQUIPMENT

— Dressmaking dummy
— Sugar paper
— Scissors
— Pins
— Tape

ACTIVITY

1. Your challenge is simple: "To transform the dressmaker's dummy into a sculptural fashion icon!"

2. Begin by holding sheets of paper up to the dummy. How can you manipulate the flat paper into three-dimensional forms? Think how you might cut, tear, fold, pleat, crinkle, dart, plait, wrap....

3. You might find it helpful to think of the areas of the body in terms of separate paper sheets. How can you build a bodice, wrap an arm, create a skirt?

4. Try things out. Manipulate paper by the above methods and then hold it up to the dummy. Do you like it? If so, pin it in place. If not, what can you do to change it. Ideas should come pouring in! If you are working as a team, discuss!

5. Think how you can combine paper manipulation techniques. What happens if you fold a piece of paper, cut into it, then open it out? Do you want your paper to look neat and precise, or rough and ready? How does it look if you screw up the paper and then open it out, as opposed to folding it carefully? How does your manipulated fabric drape (fall) or is its purpose to create structure which supports another layer?

6. As the sculpture emerges, think about the personality of the person who might wear it. Does the sculpture tell a story?

7. Think in terms of layers and let the structure build. Do not worry if early layers become hidden; you can take photos at every stage. As the sculpture grows, think about how it relates to the room. Be brave and try to make your sculpture really occupy the space!

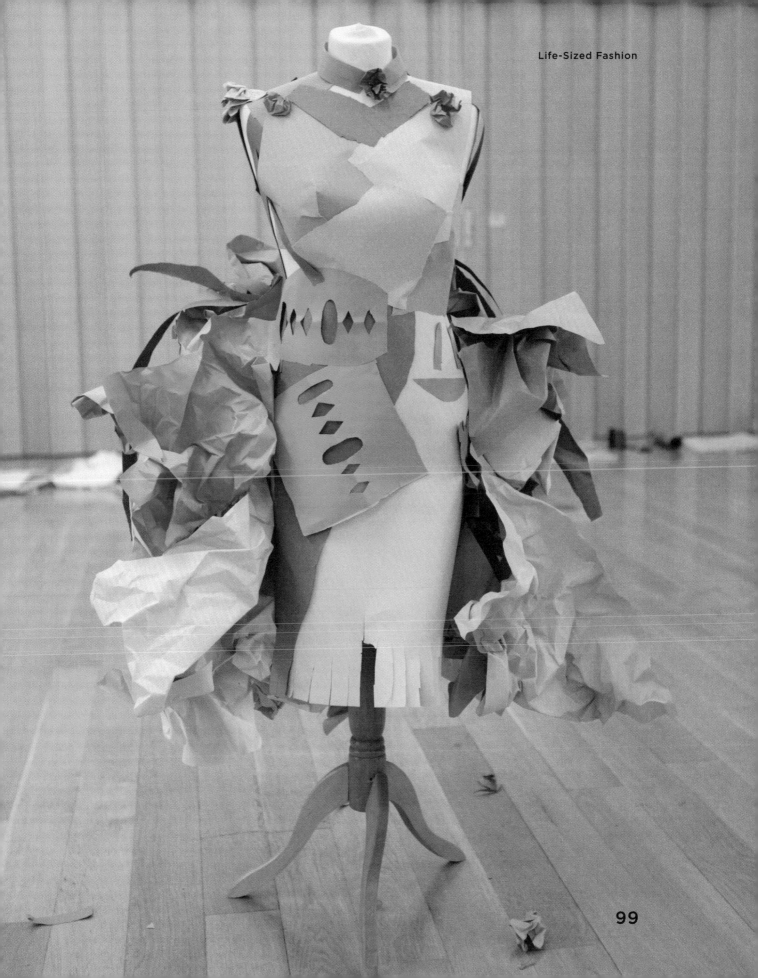

FACILITATOR'S NOTES

If more than one person is working to create the sculpture, think how best to split up the task and encourage shared creation.

One idea is to split the group into three teams, with each team working on a particular part of the dummy: top, skirt front, skirt back. Ensure the children discuss ideas as they work. Agree from the outset that it might be okay to 'rework' someone else's work (or have your own work reworked), but not to destroy someone's work for the sake of it.

This project should be free, inventive and spontaneous. Try to enable the children to create the sculpture as they work, rather than have a preformed plan or design in their head. That way they can respond to opportunities and ideas as they arise.

WHAT NEXT?

You could try using a variety of papers or fabric with distinct characteristics to give the sculpture different personalities. Use lace-like doilies or fake fur, or build structures from willow sticks that get covered in tissue paper!

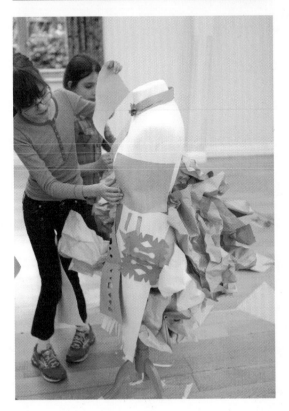

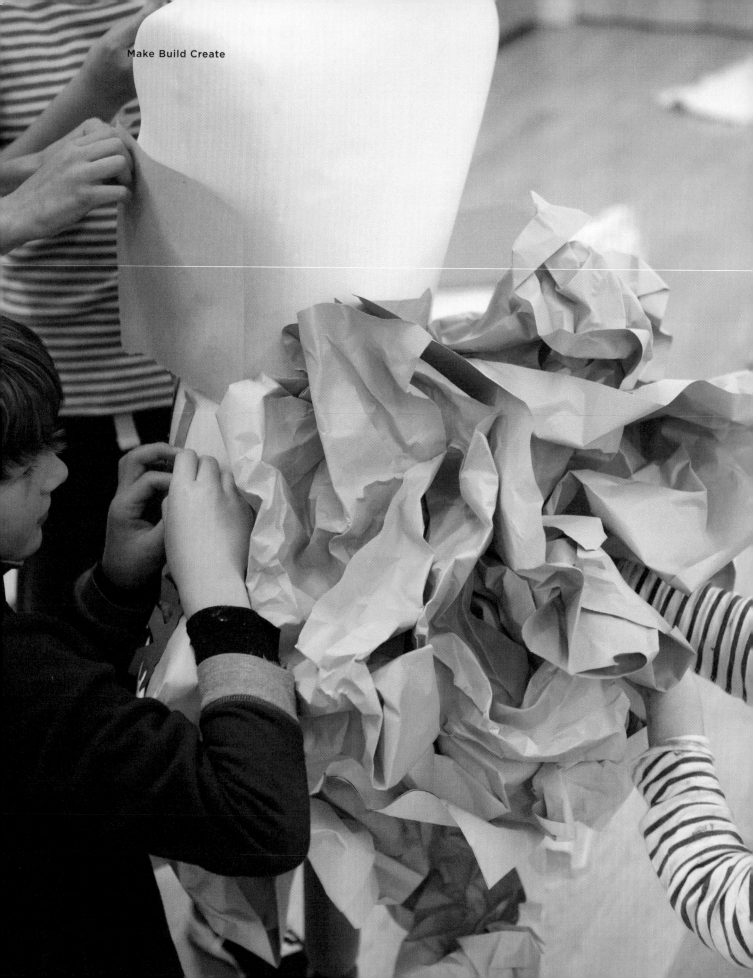

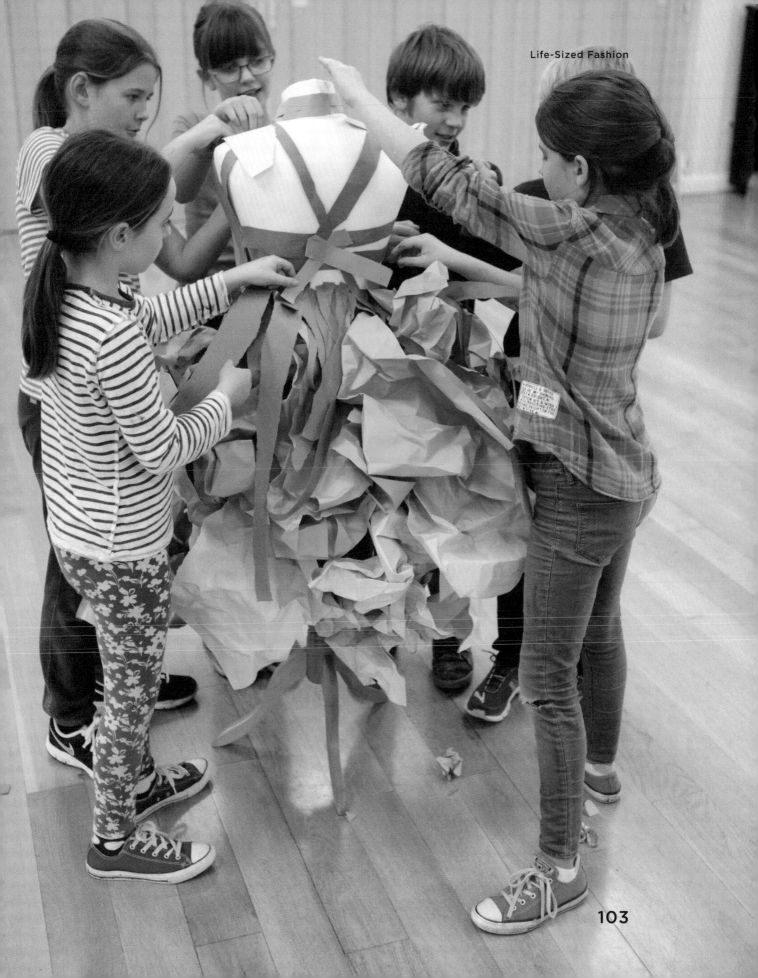

PLINTH PEOPLE

You can really enjoy creating wild and wonderful poses with these self-portrait style sculptures thanks to the way they are constructed. Allow two or three hours to complete your plinth people.

MATERIALS AND EQUIPMENT

— Fine casting plaster and mixing bowl
— Cardboard
— Wire
— Assorted fabrics, including old cotton sheet
— PVA glue
— Needle and thread
— Pliers

ACTIVITY

1. Begin by making the plaster plinths. The plinths have a clever wire embedded in them that enables the people to be in whatever position you wish, without them falling over.

2. Take a piece of corrugated cardboard that is approximately 10 x 20 cm/4 x 8 in. Roll the cardboard into a tube and tape it together. Cut a circle of card to fit the tube, and tape that in place at one end. This forms the mould for the plinth. Stand the mould in a dish or tray (to catch any plaster leaks!).

3. Cut a 30 cm/12 in length of strong but malleable wire, and bend one end into a triangular shape. This wire will be embedded in the wet plaster to form a cantilever support.

4. Mix the fine casting plaster (p 24). Give the plaster a couple of minutes to start thickening up (if you pour it straight away it might leak through the cardboard tube), and then pour it into the plinth mould.

5. Once the plaster is poured, and before it sets, place the piece of wire into the mould, bent end downwards. Make sure that the piece of wire that sticks up out of the plinth is centred and straight. You will build your person off this wire during a later stage.

6. Once the plaster has set (approximately 30 minutes), peel away the cardboard to reveal your plinth!

7. Now you are ready to make your self-portrait sculpture. Think about the kinds of activities you like, and the kinds of poses they involve. The wire which projects from your plinth can be used as a leg, an arm or a head... it's up to you.

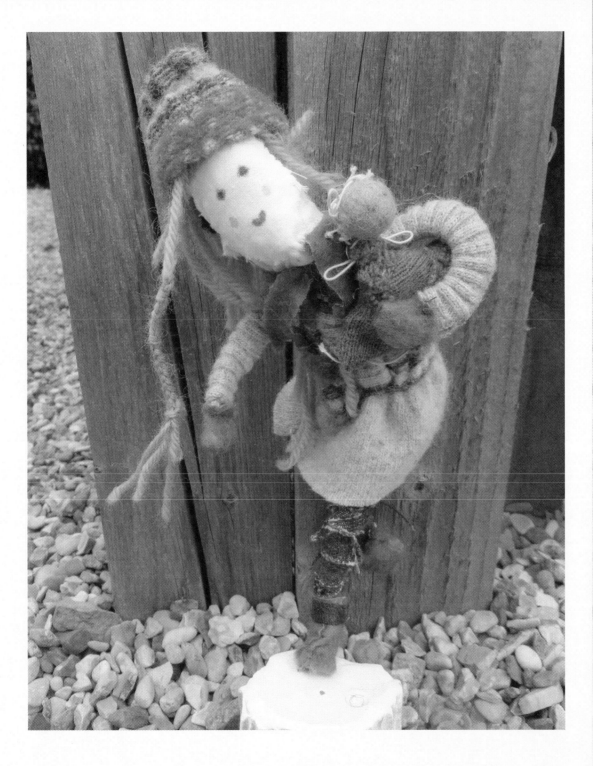

Think of a pose that is as dynamic and personal as possible.

8. Build up a stick-man figure using wire and pliers (p 36). Experiment with the position of your figure, but do not worry about details. Concentrate on main limbs, the torso and head, rather than fingers, toes and other features.

9. Next, tear some thin strips of old cotton sheet and use these to wrap around the wire figure. Think of this layer as the muscle and skin of your sculpture. Secure ends of cotton sheet with PVA glue and/or knots.

10. Finally choose fabric to clothe the figure. You can use strips of fabric and wind them over the sculpture, securing with knots and glue, or you can cut out shapes of fabric that resemble clothes and construct them around the figures using needle and thread. You can fold, pleat and drape fabric just like real clothes! Then you can add cloth or wool hair, hats and other features.

FACILITATOR'S NOTES

Making sculpture is often about creating a structure that is balanced, a valuable skill for children to learn. However this cantilever method of construction takes away that particular focus, enabling children to experiment with making dynamic figurative forms without the worry of the sculpture falling over. Encourage the children to use fabric to make clothes that are sculptural, and give clues to the personality of the sculpture. For example, folding fabric to make a dancer's skirt will instantly give an identity to the sculpture.

If you are working with many children or you are pushed for time, you may want to make the plinths in advance.

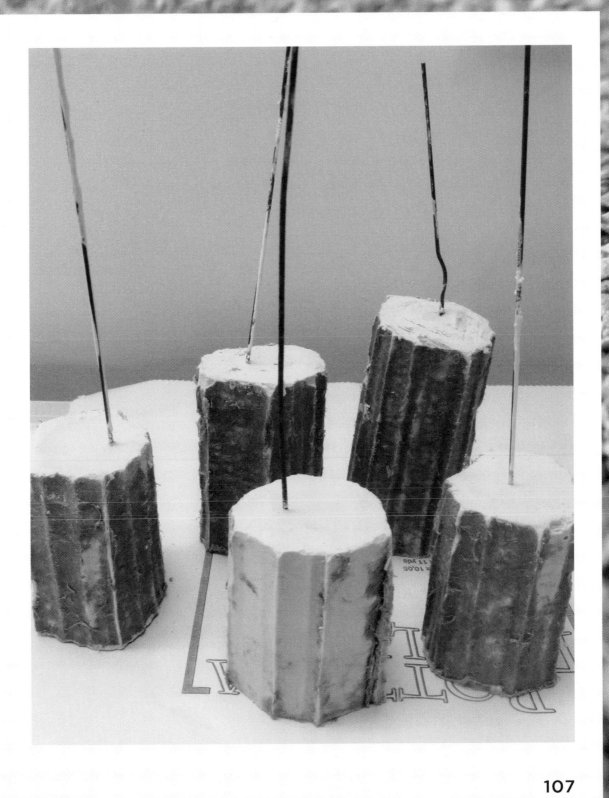

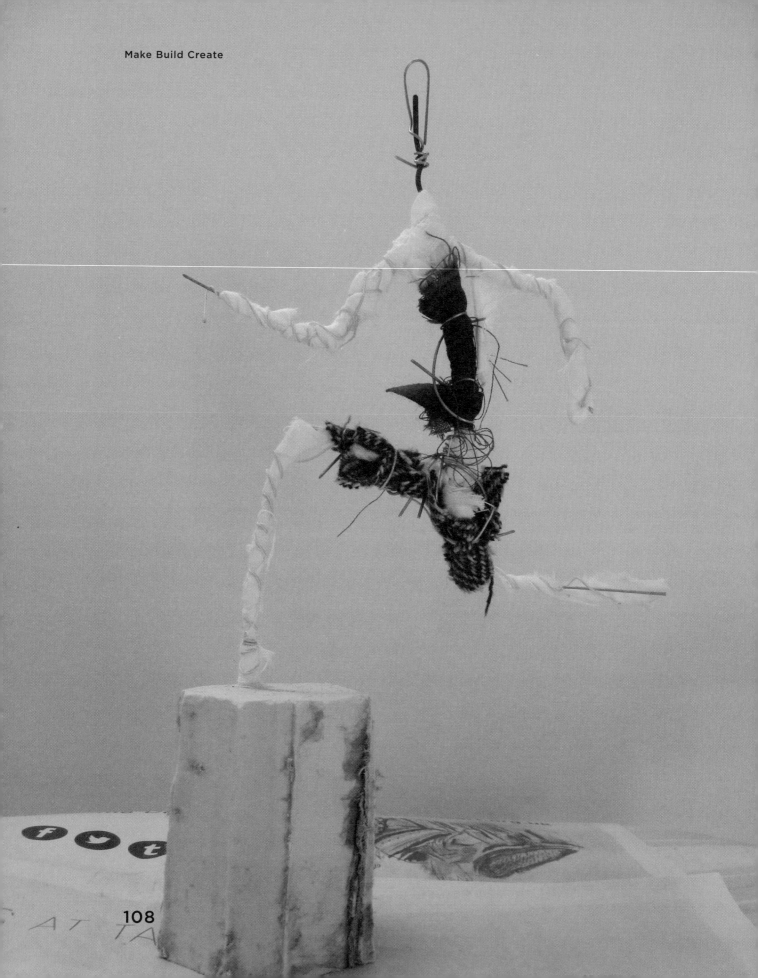

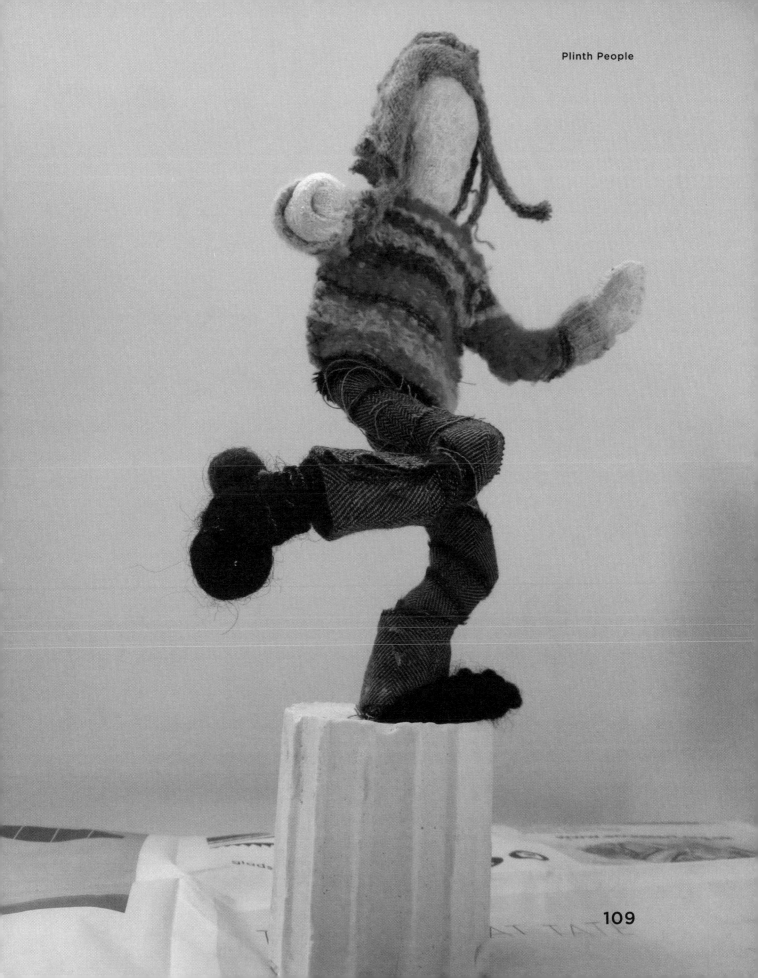

CONSTRUCTED MAPS

This project mixes typography, map-making and 3D construction skills to create visual and sculptural representations of fictitious lands that can take over your floor!

MATERIALS AND EQUIPMENT

— Large sheets of paper
— Pencils, pens and scissors
— Glue sticks and magazines
— Lolly pop sticks or other small pieces of wood

ACTIVITY

1. In this project you will be working from your imagination to create a 3D map of a fantasy land, so begin by thinking what kind of place you want to conjure up. Will it be a tropical island with lots of coves, an inhospitable mountain range or an active volcano?

2. Begin by trying out a few ideas using pencil, pen and paper. Draw rough outlines of your land and add a few sketches of the main landmarks. Think too about names, and experiment with using different fonts to add the place names to the map.

3. Once you are happy with your ideas, start work on the 3D version. Take a larger piece of paper, or connect smaller pieces together, and begin by drawing the shape of your land. If you hold your pen or pencil lightly and from the top then the line you create will be nice and squiggly, just like the outline of an island. Go over this in black marker pen and then cut or tear out the island. Use pencil then marker pen to begin to draw in any details you would like, such as roads, pathways, symbols for forests, place names, etc. Try to be diverse in your mark making so that the map looks visually interesting and begins to tell a story. Using different line weights of black pens will also help your mark making.

4. Then start building! How can you manipulate other pieces of paper to add to your land, to create landscape, objects and structures? Explore and experiment. Build up, build down and build across. How inhabited will your land become? Will you add colour or leave it monochrome? How will you build structures out of paper (and maybe sticks) that stand? Have a look at the paper manipulation techniques on page 46.

5. Pack your making session full of exploration, and at the end you can walk through a 'sea' of islands!

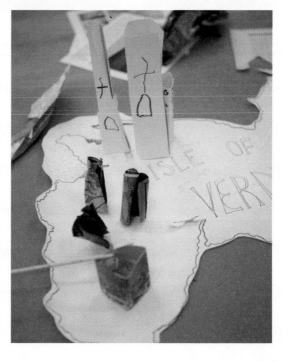

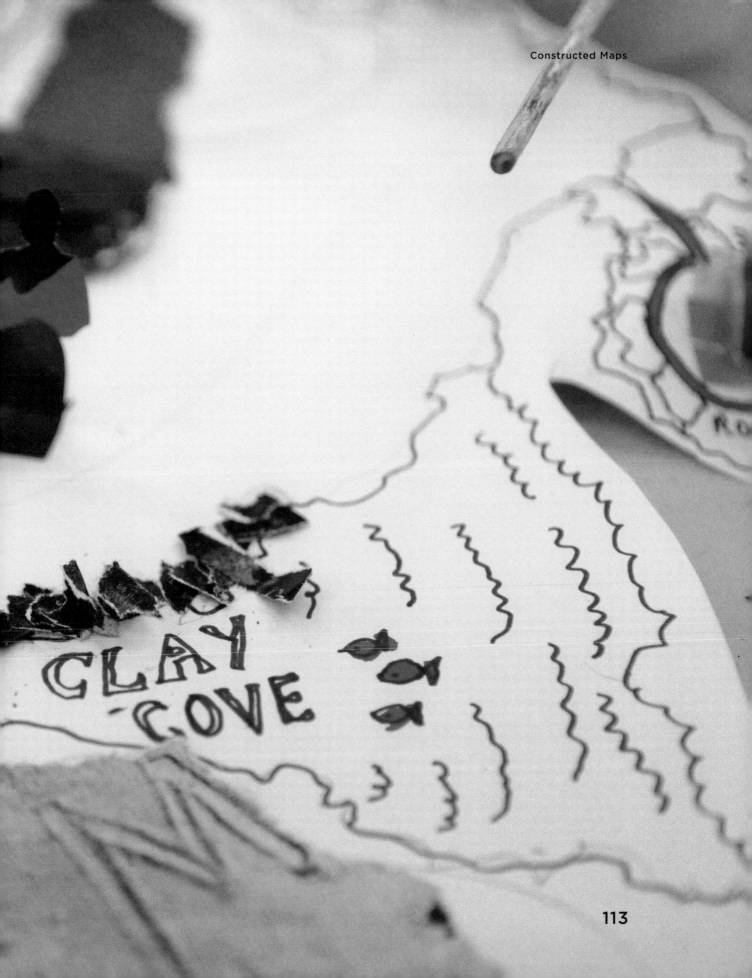

MAKING AN ISLAND PARADISE

Here is a project that you can really lose yourself in! Imagine an island with exciting spaces to explore: white beaches, rock pools, craggy cliffs and gardens. Maybe even secret passageways and treetop walk ways.... You can create it all for keeps.

MATERIALS AND EQUIPMENT

— Plastic, wood or cardboard on which to work
— Polystyrene or newspaper
— Masking tape
— Modroc
— Scissors
— Bowl and water
— Paint and/or tissue paper and PVA glue
— Brushes
— Found objects (stones, bits of pottery, shells, twigs, etc)

ACTIVITY

1. Begin by finding a board on which to build your island. You could use a piece of wood or plastic, or even cardboard, but your island might become quite heavy so make sure the board is strong.

2. To make the contours of the island, either break pieces of polystyrene and stick them down with PVA glue, or scrunch up pieces of newspaper and tape them in place. Think about the nature of your island. Do you want to create hilly ground in the centre that slopes gently to the beach and sea, or do you want to create sheer cliffs? If you want to create passageways, create them at this stage by using tubes of card. Take your time with this stage.

3. Once all your landscape is glued or taped in place, it is time to start covering the model with modroc (p 28). You can use the modroc to cover the whole structure to make it stronger and also to add modelled detail. For example you might choose to make the modroc smooth for areas of fine grassland or beach, or model wrinkles in it for waves, or pinch it into spikes for rocky areas.

4. You can also add found materials at this stagé. For example, use small twigs as trees, and use the modroc modelled around the base of the twig to embed it to the island.

5. Once the modroc is set, you can use water-based paints to add colour. Alternatively use tissue paper and PVA glue to add colour and texture. You can also use a layer of glue to stick down a sprinkle of sand or grit, or what about

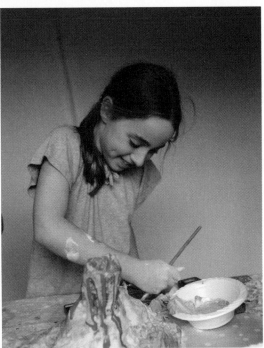

using layers of glue to add a shine to areas of water?

Wish you were there? Enjoy your island!

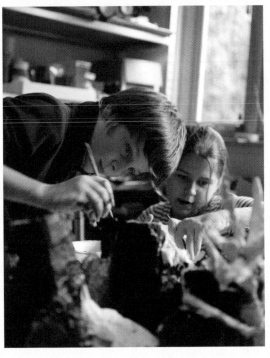

FACILITATOR'S NOTES

This project enables children to really use their imagination and to take ownership of their making. If you are working with more than one child, you could extend the project by creating an installation of many islands, and possibly getting the children to construct bridges from paper straws or sticks to connect their islands.

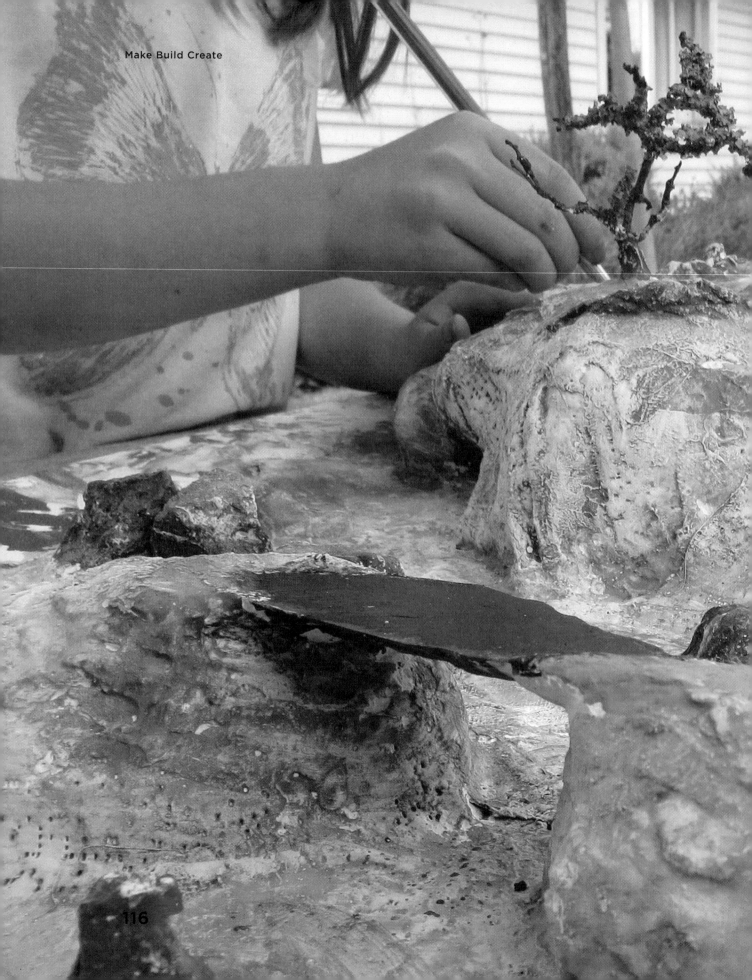

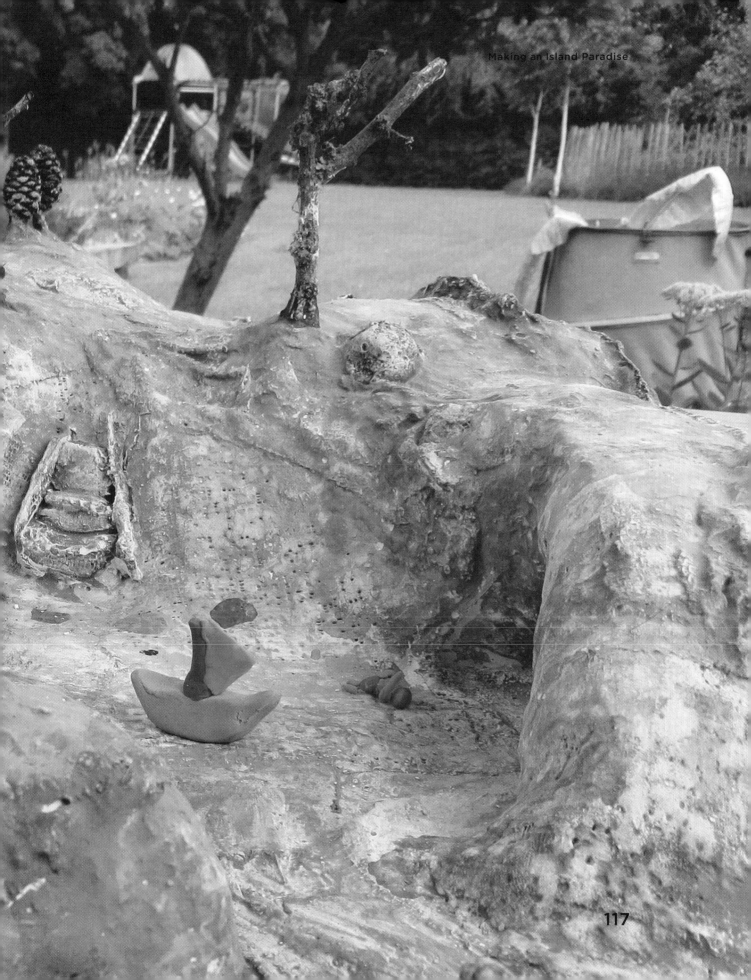

MAKING A TREE HOUSE SCULPTURE

Let your imagination go wild and make yourself a miniature tree house with accompanying slides, aerial walkways and swings!

MATERIALS AND EQUIPMENT

— Small branches/large twigs
— Terracotta plant pot
— Gravel
— Assorted card and paper
— PVA glue
— String
— Matchsticks, lolly pop sticks and other pieces of wood
— Fabric
— Other small found objects
— Scissors, brushes, etc

ACTIVITY

1. Take an empty terracotta plant pot and select a number of small branches/large twigs. Position the branches and twigs in the plant pot and use rocks and gravel to keep them upright. You might need to spend a little time arranging the sticks to get them to balance. Try to include sticks that have plenty of forks, as these will provide opportunities for you to build platforms and houses.

2. Now for the fun part. Using all the materials listed above (and more besides), think how you can create:
— round houses
— square houses
— platforms
— walls
— turrets
— hanging houses
— flag poles
— slides
— stairs
— spiral staircases
— rope ladders
— rope bridges
— wooden walkways
— bunting
— decorations
— secret passageways and trapdoors
— swings
— tight rope wires

3. Be as inventive as you can be and enjoy!

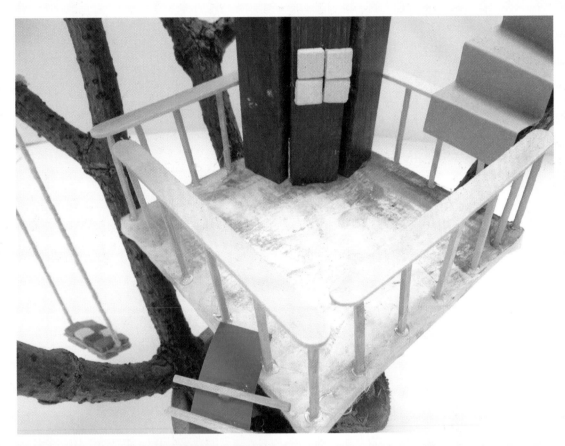

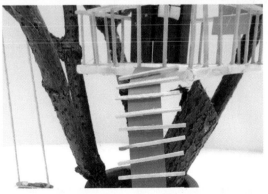

FACILITATOR'S NOTES

Children will only need to have the materials and equipment provided, permission to explore and then their imaginations will do the rest. Keep the sessions playful and exploratory. Consider making these tree houses in situ in trees outdoors if the weather permits. You might even make a whole series occupying one tree.

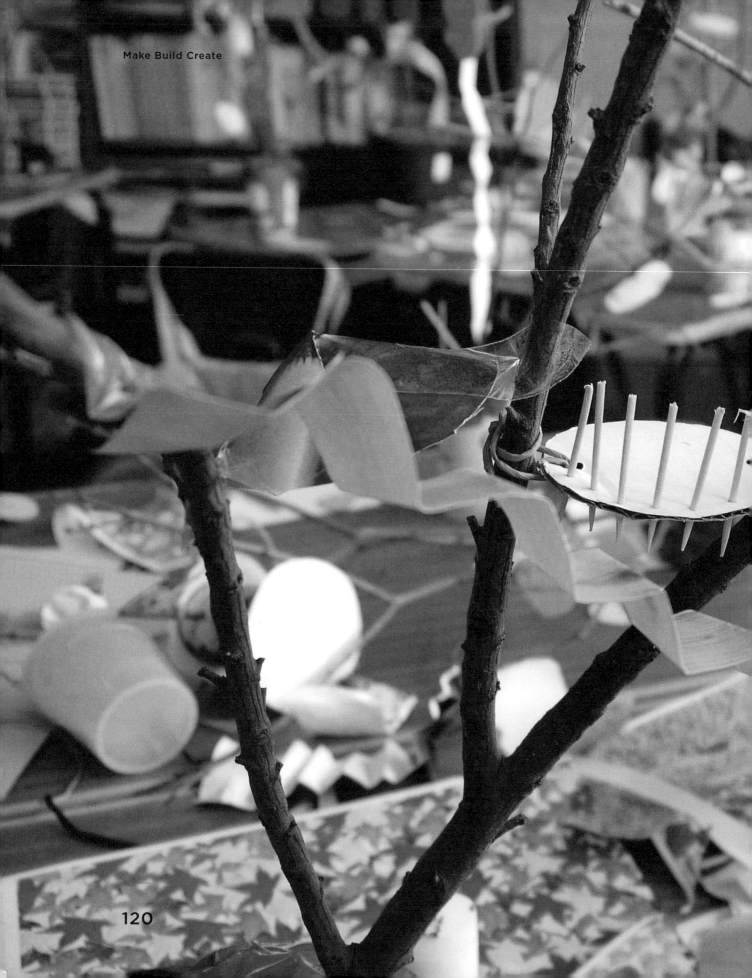

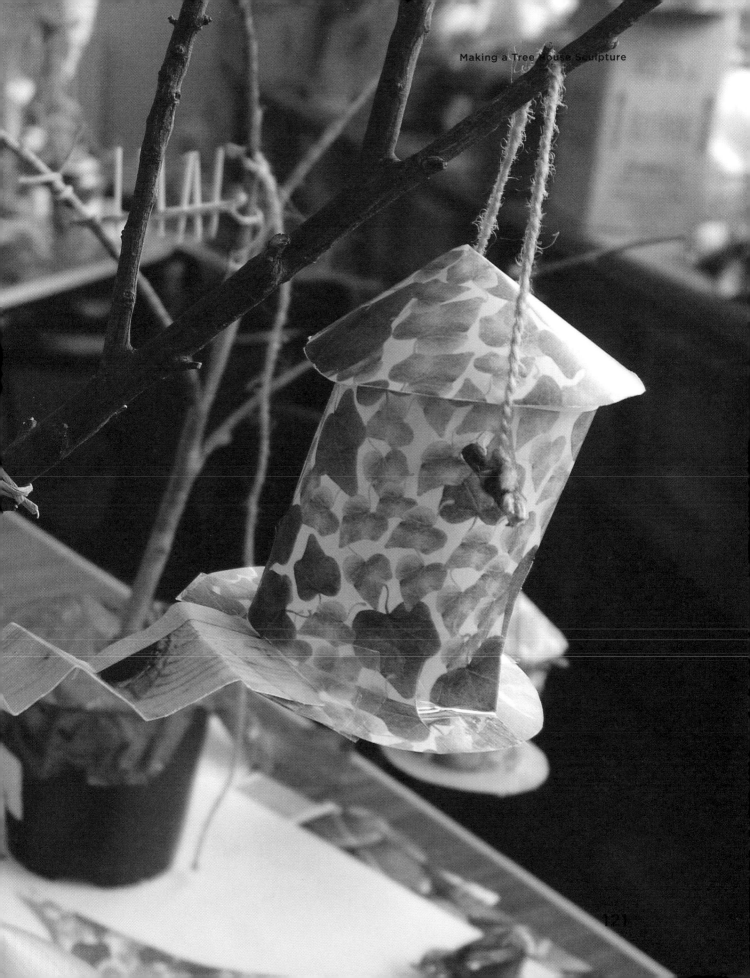

SHRUNKEN SPACES

Shrink paper is great fun! Make your drawings on clear or white plastic and then watch them shrink to a seventh of their former size. The finished, shrunken drawings make wonderful elements with which to make sculpture!

MATERIALS AND EQUIPMENT

— Plain white and/or transparent shrink paper
— Permanent marker pens
— Pencils and pencil crayons
— Thick card for a base, and thin card for fastening the elements
— Glue spots/strong PVA glue
— Scissors
— Oven

ACTIVITY

1. Before you start working with the shrink paper, think about the kind of space you would like to create. Perhaps you would like to make a party with lots of dancing characters, flashing lights and party food. Or perhaps you would prefer to create a classroom, cafe or street. Which elements (people and objects) would you like to make to help build these spaces?

2. Begin by drawing simple characters on sheets of shrink paper. If you are using the clear shrink paper, only permanent markers can be used to make the drawings, but if you use the white shrink paper and work on the rough side, you can use permanent markers, pencils and pencil crayons to create the drawings. Fill the page, and as you draw remember that your drawings will shrink to one seventh of their size, so do not make them too small!

3. Make sure you also draw architectural elements that will help you build the space. These might be walls, doors, columns, roofs or archways.... Experiment and cut holes in walls to act as windows.

4. Cut out the figures and objects. Ask an adult to help you shrink the paper, according to the instructions on your particular shrink paper.

5. Take a piece of cardboard to act as a base for your space. Now use your shrunken elements to build a space! Resist sticking the elements down straight away and instead play with the pieces to see how they might work together. Enjoy playing with a sense of perspective, looking through the spaces into your miniature world.

If you feel you need to, create extra architectural elements using card and a black pen.

6. Once you have decided how you want your objects/people to exist in the space, use small tabs of paper or card to fasten the pieces to the base.

FACILITATOR'S NOTES

This project gives children the opportunity to explore how they might create groups of figures, and also create the space in which the groups exist. By working with individual elements (characters, objects, architectural shapes), the children can use a sense of play to experiment with building an occupied space that tells a story.

Children love using shrink paper. The end results are captivating as the mark making shrinks down too. The plastic becomes thicker so the end results feels permanent and product-like.

You might prefer to spread this project over two sessions that will allow you to bake the shrink paper away from the children. You may also like to make a few additional architectural elements which the children can use as they wish, rather like building blocks, to extend and inspire their spaces.

123

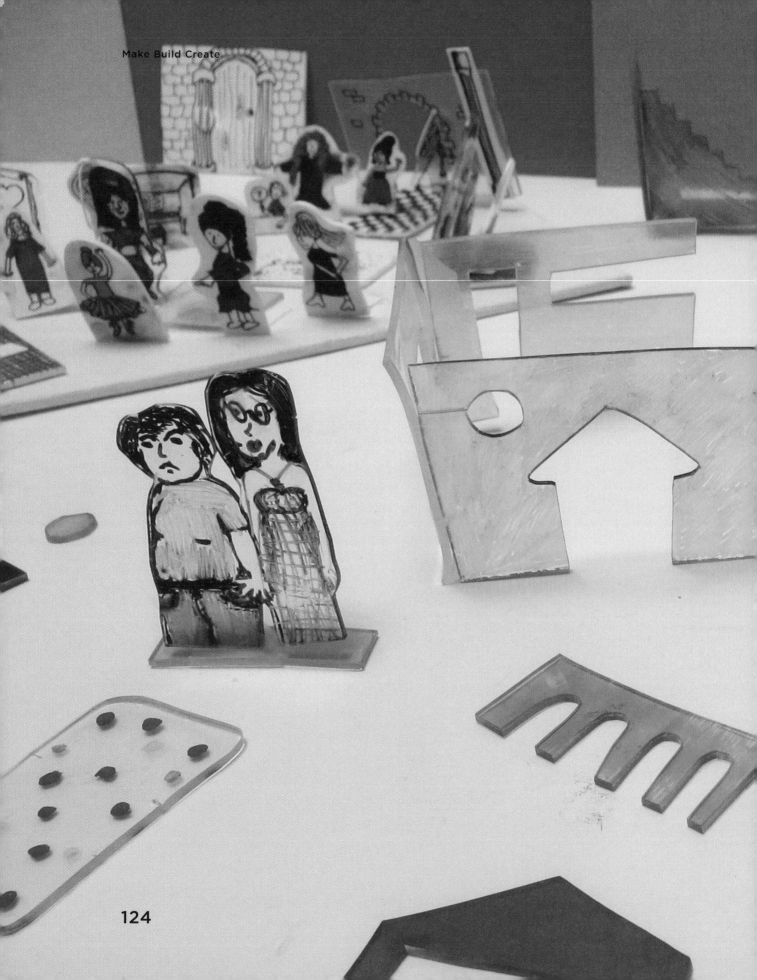

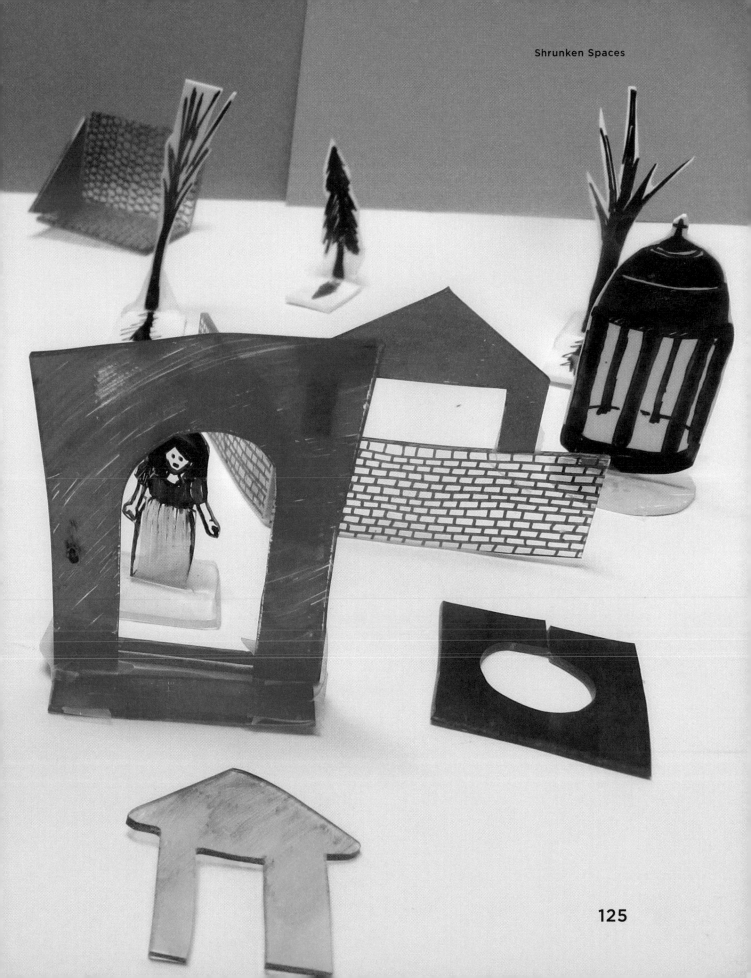

TAKE A SEAT

We might take chairs for granted but they can actually be incredible works of design, capable of infinite variety and personality! Be as inventive as you can be and have fun making mini chairs in all different shapes and materials.

MATERIALS AND EQUIPMENT

— A wide variety of construction materials: fabric, wire, wood, paper, etc
— PVA glue
— Pliers and a hacksaw

ACTIVITY

1. Before you start work, take a few minutes to look at chairs around you and on the internet, to appreciate what a chair might be. We know most chairs have four legs (but not all!), and a seat or a back (not all!), but how those elements are designed and made is up for grabs!

2. Try not to 'design' your chair in your head or on paper. Instead go to the pile of materials, and working with your instinct, choose the materials that you like the look of. Ideas will be sure to come to you as you look at the materials.

3. Begin building your chair—be inventive, take risks and do not be afraid to try!

4. Work methodically when you need to. Fasten materials together with strong PVA glue. A good tip is to make home-made tape out of strips of fabric covered in glue, and use these as hinges or bandage to secure joins. You will make your job easier if you work in stages and allow joins to set before moving on.

5. Watch as each chair you makes takes on its own personality!

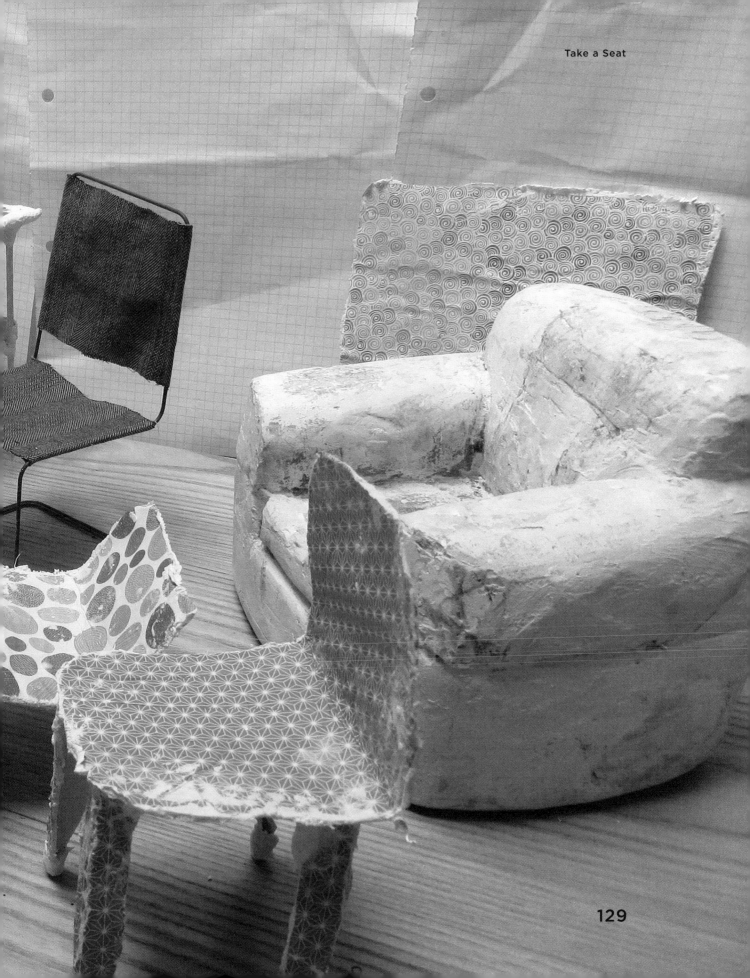

MY HOUSE

There is something special about transforming an ordinary, everyday material into an extraordinary object. These autobiographical architectural sculptures use corrugated cardboard, laid in strips on their side, to create sculptures designed to be peered into!

MATERIALS AND EQUIPMENT

— Corrugated cardboard
— Strong scissors
— PVA glue and brushes
— Decorative paper/materials

ACTIVITY

1. Begin by cutting lots of thin strips of corrugated cardboard. The strips should be about 1 cm/⅜ in wide, and cut against the corrugations.

2. Take another piece of cardboard which will form the base of the sculpture. Take a moment with the base in front of you, to think about what you are about to build. What does your house look like? How many storeys does it have? How many windows? Does it have a front porch? How does the roof slant?

3. Begin work by creating a plan of the front of your house, as if seeing the house from above. Use the strips of card to plot out the shape of the front and sides of the house. Once you are happy, glue these lines in place with PVA glue.

4. Continue building up to create the front and sidewalls of your house. Layer the cardboard strips and glue them in place. Leave gaps for windows and doors, and make your walls stronger by staggering joints.

5. Keep working until you feel the walls are high enough, and then start to make roofs out of single pieces of card, or construct with cardboard roof tiles. You may decide only to attach your roof on one side so you can flip it up to see inside.

6. Because you have only been building the front and sidewalls, the back of your house should be open. Use this open space to give you access to the inside of your house. Would you like to add floors and stairs? Objects in your bedroom? Or just leave it open? It's up to you! Enjoy the differences between the front and back of your sculpture.

7. When you have finished take a moment to get down at eye level with your house and peer in! Enjoy how the layers of corrugated card let the light flood through, and yet make a strong construction.

FACILITATOR'S NOTES

In this activity children start out by making a structure based upon their knowledge of their own house, but during the making process, the house will of course take on its own character. Encourage this departure and try to help the children be aware of when they shift from making a model of their own house, to creating their own sculpture. The point at which they really take ownership of their work is to be celebrated!

As facilitator you may wish to prepare for the project by cutting up the cardboard strips. Using a sharp craft knife will speed this up and ensure the cardboard strips have nice clean lines.

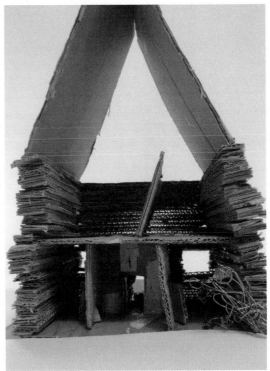

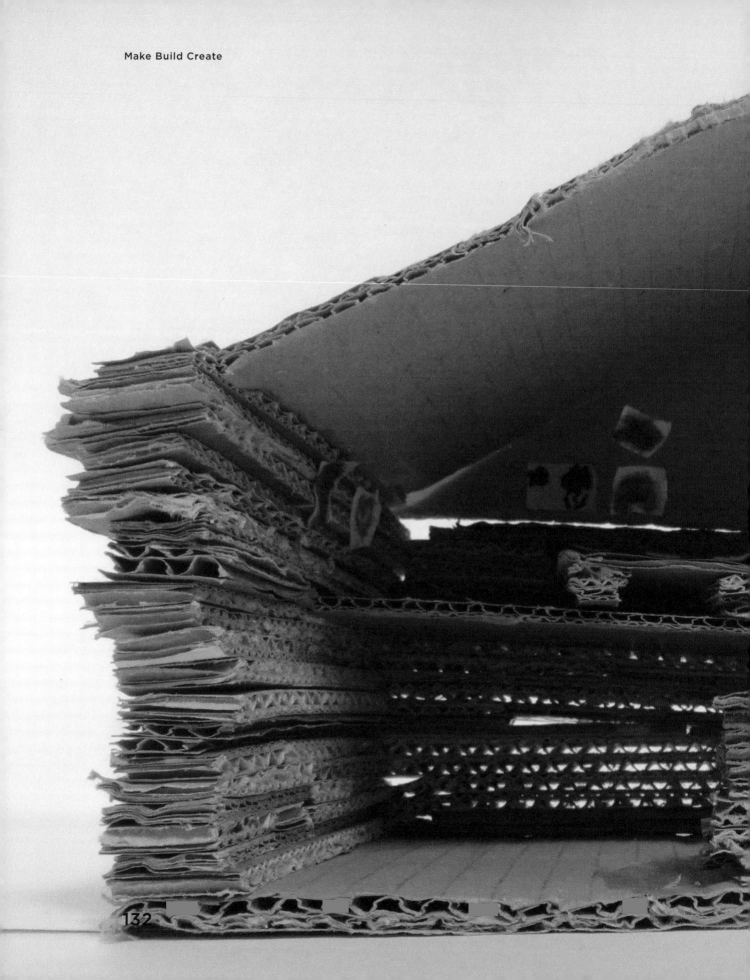

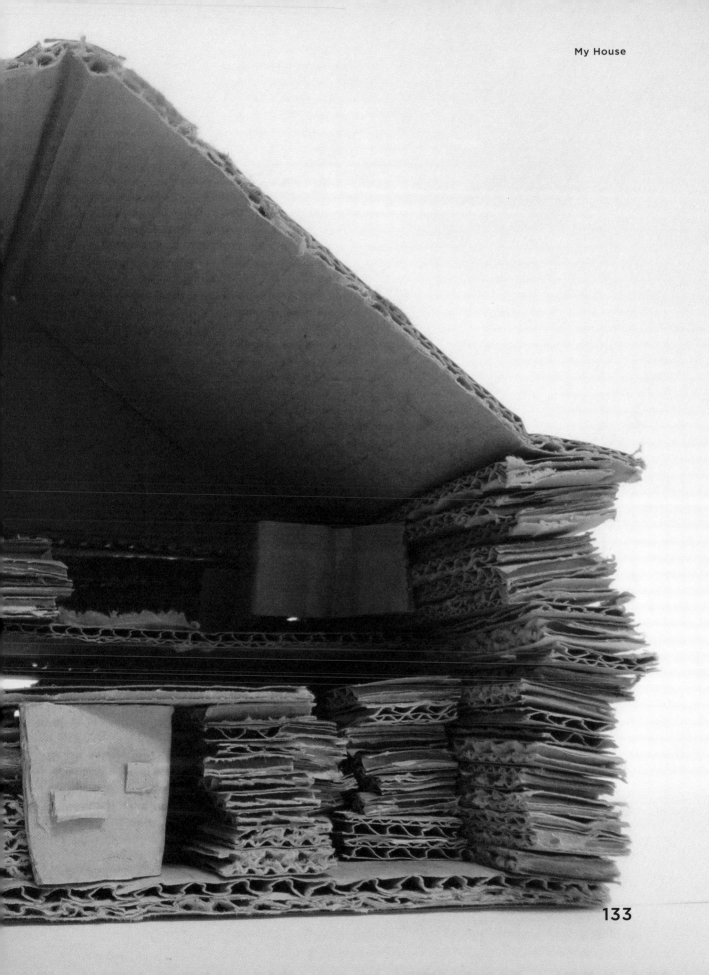

BE AN ARTIST

In this very creative project, you get to build yourself a studio as well as making mini art to go in it! You can really indulge in your dreams in this project and imagine what kind of artist you might like to become....

MATERIALS AND EQUIPMENT

— 6 mm/¼ in plywood (or cardboard)
— Wood adhesive (or PVA or a glue gun if you use cardboard)
— A wide selection of making materials (wire, card, pieces of wood, fabric, paper, dowel, etc)
— Pens and pencils
— Scissors and pliers
— Hacksaw and bench hook

ACTIVITY

1. First build yourself a mini studio. Begin by cutting plywood into squares approximately 20 x 20 cm/8 x 8 in. Ask an adult to help with the sawing. Plywood gives a really strong finish to the studio, but if you prefer you could use cardboard. Cut three plywood squares and use one as the floor and two as walls, forming a corner. You might even decide to make a window by sawing a section out of one of the squares.

2. Use wood glue to attach the walls to the floor and allow it to set.

3. You may decide to leave the plywood untreated, or you might want to paint it, or even layer another material on it—for example a wood veneer for the floor.

4. Now is the time to get really creative! Look at some pictures of artist's studios on the web, and you will see what exciting places they can be—full of materials and tools and half finished artwork, drawings, notes.... The furniture in artist's studios is often quite makeshift: if an artist wants some shelves they rarely buy them, instead they'd make them roughly out of old timber. An old chair might be rescued and rehomed, or a desk made out of an old door. Artist's studios are often in flux: always changing. Enjoy feeling free to create an exciting creative space. What materials can you find around you which you can recycle into furniture for your studio?

5. Once you have created your furniture, turn your attention to making mini artwork. This is a great opportunity to enjoy taking risks in your work, but on a small scale! If you've often dreamt of painting huge canvases now is your chance—make a small canvas and splash paint on to it, and when you put it in

134

your studio it will suddenly seem huge! Or perhaps you'd like to build sculptures out of found materials. Be playful. And don't forget to think how you might want to use the walls of the studio as a pinboard for your mini sketches, or to make mini sketchbooks and pencils for your desk. Or maybe you'll create a whole pile of mini materials as your store cupboard. Don't worry if you don't have a clear idea of what to make—just pick up some materials and an idea will come to you.

6. You could even create a gallery space so you can curate exhibitions of your mini art in a clear space away from the clutter of your studio. Or why not build a whole art school!

7. Finally, take a camera, get down low and take some photographs of your studio!

FACILITATOR'S NOTES

If you are using plywood, having lots of pieces of wood pre-cut can help liberate the children. They can then search for the pieces they need and be inspired by what they find. In this project, consider yourself to be the technician for the children, helping them build their dreams.

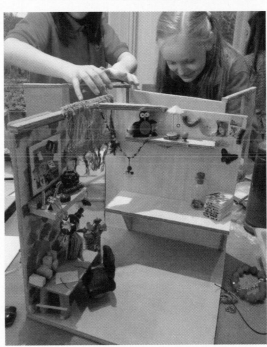

Rowan's studio

GLOSSARY

ADDITIVE PROCESS

An additive process is one in which the sculpture is built up bit-by-bit, like for instance in the clay models. An additive process is the opposite to a subtractive process.

ARMATURE

An armature is an internal structure that supports the sculpture.

ASSEMBLAGE

Sculptures constructed from found objects.

CARVING

One of the oldest sculptural techniques. Carving is a subtractive process, in which the maker takes away pieces of material (such as wood, stone or plaster) using a tool.

CASTING

Casting is a process which either enables us to transform the material with which an object is made, or helps us produce more than one copy of an object. To cast an object we need to make a mould.

MODELLING

Modelling is an additive process in which the maker adds small pieces of a soft material, such as clay, to make the sculpture. Modelling can also involve using tools (or fingers/hands) to help remove or shape small pieces of material to help make the sculpture.

MOULD

A mould contains an impression of a sculpture and is used to make a cast.

AFTERWORD

When I think of my childhood, I think of making. As I shaped the things I made, making shaped my childhood.

I think of the day I cried because I didn't want to go to reception class because I wanted to stay at home to work on my cardboard dolls house. I think of the joy of a new pack of Plasticine. I think of soft-coloured wax that I could mould with my fingers into my version of the edible garden in *Charlie and the Chocolate Factory*. I think of melting wax crayons over a candle flame, dropping the wax on to card to make 3D pictures (and I remember the small stub of wax crayon I stole from school, pushing it down my white knee length sock because it was just the right colour). I think of building houses out of matchsticks and being entranced by a small tool that let me cut the matchsticks to size. I think of digging up our clay soil from the garden, mixing it with water, letting it settle and scooping the clay layer out. Letting it dry on a plaster bat and trying to use it as modelling clay. I think of the endless hours spent sewing with my mum and sister making soft toys and clothes. I think of making a model village for the local village show, and making Christmas decorations whilst in a hospital bed. I think of visiting potteries on holidays in Wales, fascinated by those clay-ridden studios. I think of dreaming my wardrobe was full of paper and card, and waking disappointed to remember it was full of clothes. I think of the pleasure of tools: a gift of old Sheffield chisels from the elderly man up the road, and a drill for my 18th birthday. I think of collecting a gnarled old Hawthorn branch from the Derbyshire Moors, and bringing it home to carve.

And I think of the complete and utter sense of belonging I felt, walking down the steps into the basement at what was then the Norwich School of Art, into the shanty-town studios where everyone else who had spent their childhood making things, were squirreled away, continuing with their journey.

And I think of the pleasure I have had over the many years since, making things with my daughter, and working with my friend and colleague Sheila to help others discover the joy in making.

I no longer have any of the objects I made in my childhood, but as an adult I feel completely formed by the fact that I made them, which leads me to think that the act of making is as important, if not more so, than the objects themselves. And that is what we need to protect.

AUTHOR BIOGRAPHY

Paula Briggs received a 1st Class BA (Hons) in Fine Art (Sculpture) at Norwich School of Art, before going to the Royal College of Art, London to receive an MA Sculpture degree.

Paula has worked for over 20 years with her colleague and friend Sheila Ceccarelli. Together they set up Cambridge Sculpture Workshops in 1995, and in 1999 established the UK charity AccessArt, which aims to inspire and enable high quality visual arts, teaching, learning and practice. AccessArt has become the leading provider of artist-led and artist-inspired digital resources for use by teachers, facilitators and creative practitioners. Find out more about AccessArt and sample resources at www.accessart.org.uk.

In 2015, Paula was the author of the book *Drawing Projects for Children*, also by Black Dog Publishing. Paula continues to co-manage AccessArt and in addition to directing website content, continues to teach a wide audience of children, young people and adults in the Cambridgeshire area.

ACKNOWLEDGEMENTS

Thank you Mum for keeping my "making box" replenished with all those pots and bits and bobs, sitting me on the stool at the work surface and endlessly passing me what I needed, and then appreciating what I made. Thank you Dad for having patience with me in your darkroom, enveloped in that magical (and smelly) world of developer and fixative and photographic transformation.

Thank you Sheila, my valued friend and colleague from AccessArt and my fellow inspirer, for helping keep the making momentum moving ever-forwards!

Thank you David for your patience with the tide of materials and projects that ebb and flow from the house, and for being patient with the fact that we don't often see the surface of the dining room table (as you say the equivalent of having a car engine in the house).

And here's to the next generation of makers (my daughter Rowan included) who think and act through their hands with as much rigour, determination, passion and commitment as any scientist, mathematician, engineer or doctor employs in their sphere of work. Let's support them whenever and wherever we can.

Many thanks also to Rita Pereira and Albino Tavares at Black Dog Publishing for creating such a beautiful book, and to Emma Holland for all her hard work in editing the text.

COLOPHON

© 2016 Black Dog Publishing Limited, London, UK and the author.
All rights reserved.

Black Dog Publishing Limited
10a Acton Street, London WC1X 9NG
United Kingdom

Tel: +44(0)20 7713 5097
Fax: +44 (0)20 7713 8682
info@blackdogonline.com
www.blackdogonline.com

Designed by Rita Pereira at Black Dog Publishing.

All opinions expressed within this publication are those of the author
and not necessarily of the publisher.

British Library Cataloguing-in-Publication Data.
A CIP record for this book is available from the British Library.

ISBN: 978-1-910433-70-6

No part of this publication may be reproduced, stored in a retrieval system,
or transmitted, in any form or by any means, electronic, mechanical, photocopying,
recording, or otherwise, without prior permission of the publisher.

Black Dog Publishing is an environmentally responsible company.
Make Build Create is printed on a sustainably sourced paper.

Paula Briggs' *Drawing Projects for Children* is also available from
Black Dog Publishing, ISBN: 978-1-908966-74-2.

art design fashion
history photography
theory and things

black dog
publishing

www.blackdogonline.com london uk

ALSO AVAILABLE

Drawing
Projects
for
Children

Paula Briggs

black dog
publishing

Informative and inspiring, *Drawing Projects for Children* is a beautifully illustrated collection of activities that will expand the mark making abilities and imagination of children of all ages.

A series of skill-perfecting warm up exercises and over 25 exciting and innovative projects, including drawing by torchlight and creating monoprints, will help children explore ideas, techniques and a wide range of materials.

With clear step-by-step instructions and projects categorised by difficulty level, *Drawing Projects for Children* is easy for children to use independently, and the perfect tool for adults wishing to introduce children to drawing, whether in a one-to-one home setting or a classroom environment.

Drawing Projects for Children follows Black Dog Publishing's previous publication *Drawing Projects: An Exploration of the Language of Drawing*.